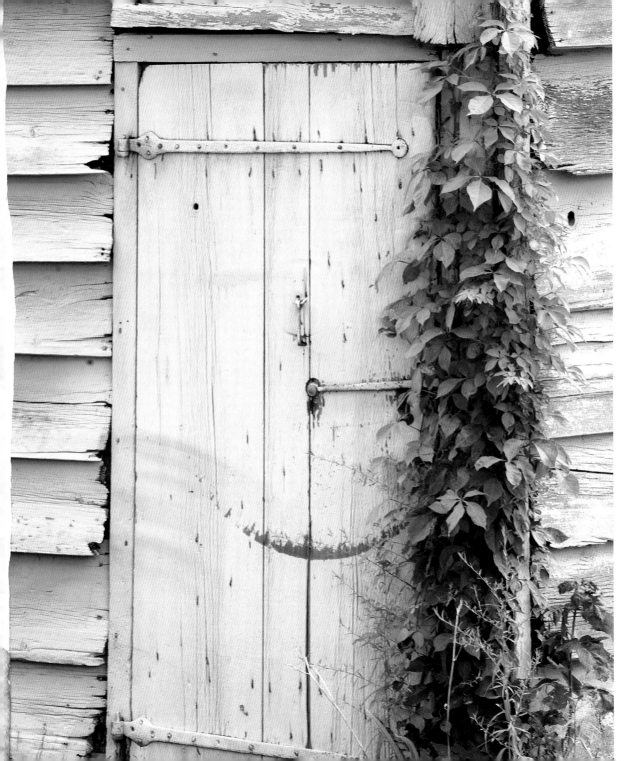

Barns of
Connecticut

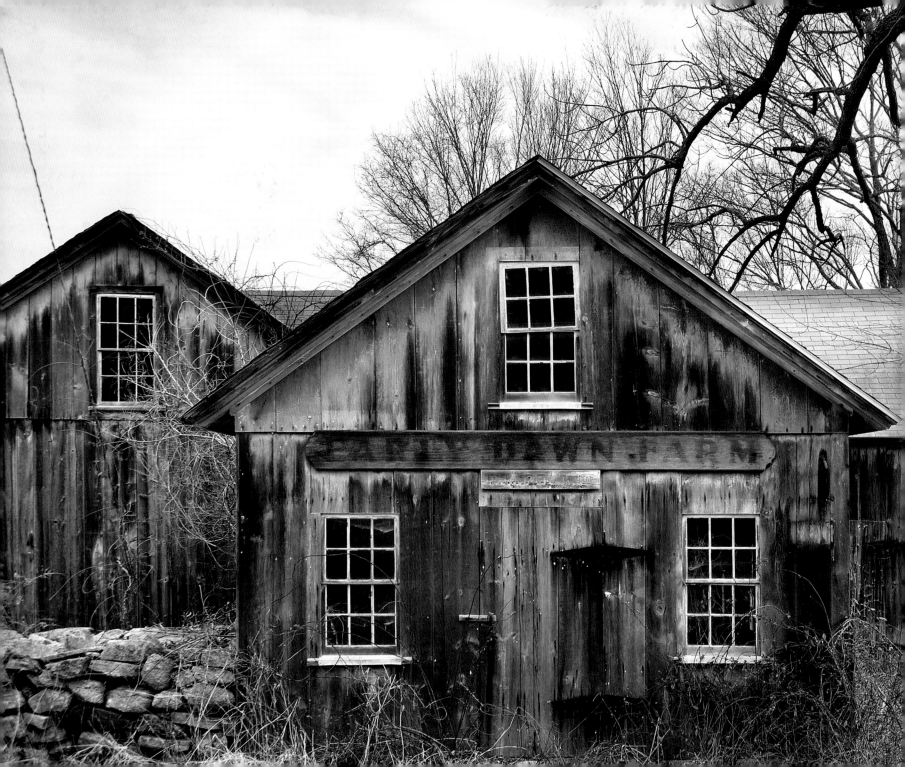

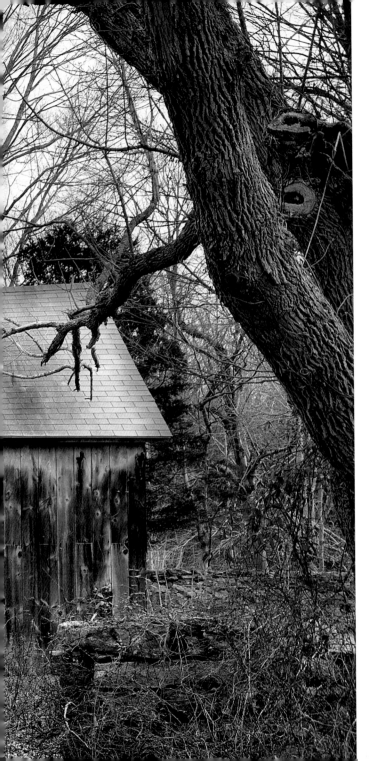

Barns

of CONNECTICUT

MARKHAM STARR

Wesleyan University Press
Middletown, Connecticut

Wesleyan University Press

Middletown CT 06459

www.wesleyan.edu/wespress

© 2013 Markham Starr

All rights reserved

Manufactured in China

Designed and typeset by Eric M. Brooks

in New Baskerville and Egiziano

This book has been printed on paper certified
by the Forest Stewardship Council.

Library of Congress Cataloging-in-Publication Data

Starr, Markham.

Barns of Connecticut / Markham Starr.

pages cm. — (Garnet books)

ISBN 978-0-8195-7403-9 (cloth: alk. paper) —

ISBN 978-0-8195-7404-6 (ebook)

1. Barns—Connecticut—Pictorial works. I. Title.

NA8230.S73 2013

725'.37209746—dc23 2013012738

5 4 3 2 1

Contents

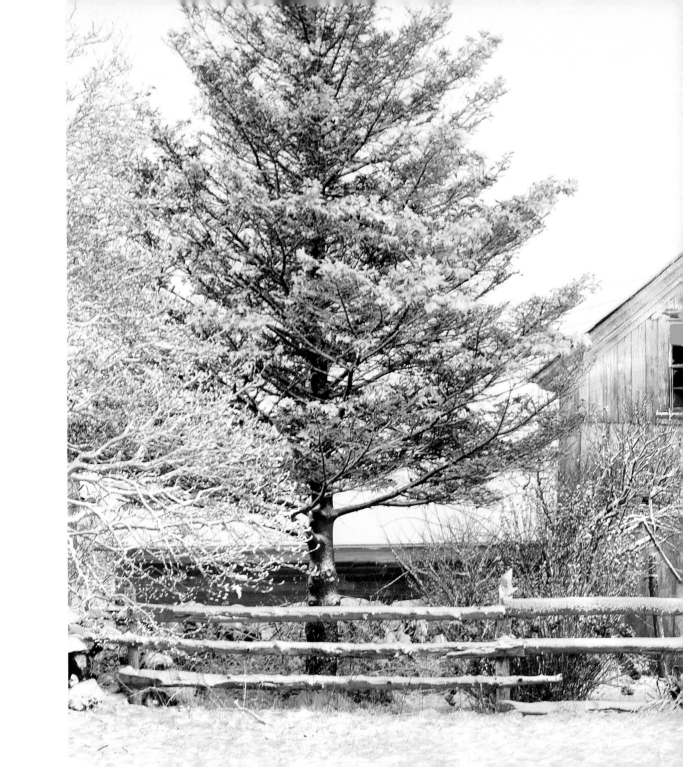

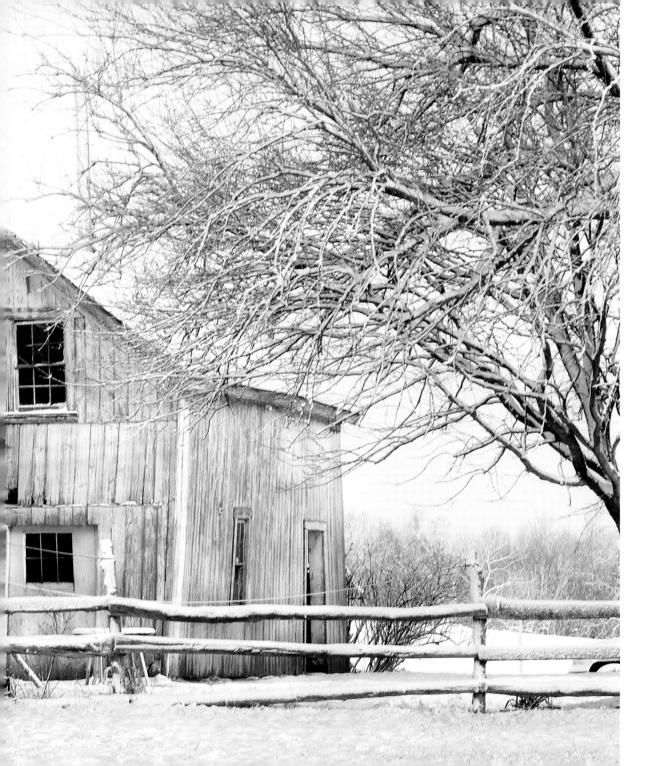

Barns of
Connecticut

If you have ever walked into an old barn, you can probably still recall the emotions you experienced. If you have never been in such a building, I suggest you avail yourself of the first opportunity. The colors, textures, and aromas inside a barn bring back the past as few buildings can. For me, walking into a barn is as close as I can get to walking into history. Old churches, town halls, and antique homes, perhaps a bit drafty by modern standards, may retain the barest memory of the years they've absorbed. Electrical and plumbing systems, however, as well as a hundred other modern transformations, often mask the essence of what it meant to inhabit such a dwelling a century ago. Barns, on the other hand, seldom undergo such transformations. The dust of decades still rests atop timbers long exposed to the passage of time. Webs cast by spiders long since departed festoon the corners, and dried animal dung adds pungency to the air. There is a palpable feeling of the life that once infused the barn.

Early Connecticut barns consist of little more than four walls, a gable roof, and perhaps two doorways. A few windows, if any, illuminate the completely open floor plan within the deceptively simple structure. Nevertheless, for the first European settlers in Connecticut, as with nearly all emerging agricultural societies, the barn's important role can hardly be overstated. In fact, as a measure of their importance, barns were once considered military targets in times of war. The British destroyed them during the American Revolution, as did General Sherman a hundred years later in his devastating March to the Sea. A population could be brought to its knees through the destruction of its barns.

While we often think of the church as the most important building in colonial life, it was in fact the barn that held survival's key. Not until basic necessities were well secured could townspeople begin to consider building a house of worship. Barns often came even before houses in order of importance. In early English history one building often served all purposes, and people, animals, and harvests all shared the same space. Without the barn, agricultural life in colder northern climates could not have flourished. Once societies moved beyond the primitive hunting and gathering model that had sustained them for millennia, storehouses became essential

Introduction

to their year-round survival. Settlers arriving in Connecticut in the mid-1600s came from an agrarian heritage, and the barns they built spoke of the culture in which they were embedded. Early Connecticut barns reflect a European heritage in their importance, design, and construction. The model for these buildings was so successful that it would be nearly two hundred years before Connecticut barn builders would consider change.

With this notion of the barn's importance to Connecticut's earliest European settlers—and my own fondness for them—I set out to write this book. Greatly aided by the Connecticut Trust for Historic Preservation's Barn Survey, I tried to identify some of the most important barns in the state. This book is not an exhaustive study, but rather a showcase of this marvelous structure in many of the forms that grace our land.

This book is also, I hope, a tribute to the continuing, and continually reflowering, family-farm culture of the state.

The First Barns in Connecticut

When early settlers populated the state, nearly every homestead required a barn of one size or another. Barns held the essentials of life. Horses and oxen used for transportation or work were stabled in the barn. Cows, pigs, chickens, and sheep also required a barn, to moderate winter temperatures and keep predators at bay. Grains and grasses grown to feed farm families and their livestock were stored within these buildings, alongside the animals themselves. And, of course, farmers stored essential field equipment there. While early barns seem humble in appearance, the role they fulfilled was anything but. Our ancestors survived on the three basic essentials: food, clothing, and shelter, and the barn played the leading role in that equation.

The first European settlers in Connecticut were Dutch, following Adriaen Block's explorations of the coastline in 1614, but English settlers transplanted from Massachusetts soon followed the Dutch into the Connecticut River valley. By the mid-1600s, the English had become the predominant European population.

The very first structures built in New England were, by necessity, quite crude. Rough log structures and earthen homes protected settlers as they cleared land and began to establish themselves and their

farms. As soon as circumstances permitted, these early settlers constructed traditionally framed structures like those they had left behind. The earliest surviving home in Connecticut, the Henry Whitfield house, was built of stone in 1639. The oldest timber-framed home in the state is the Joseph Loomis homestead, built one year later, and a dozen or more framed houses constructed before 1700 still stand. These early structures mimic the framing traditions from which they sprang. No Connecticut barns from the 1600s are known to have survived, but we can see some of their foundations and sense their structures from seventeenth-century paintings, drawings, and literature.

Since the earliest house frames in both Connecticut and Massachusetts closely follow English framing traditions, it may be safe to assume that both the design and construction details of the first barns in Connecticut did as well. The building method settlers used, known as post-and-beam construction, employed heavy hewn timbers to form the barn's skeleton, upon which barn builders applied a sheathing of sawn boards. The roofs, which may initially have been thatched, would be covered with split wooden shingles. This design was so successful for the single-family subsistence farmer that such barns were still occasionally being built even into the twentieth century. Post and beam barns are still built on occasion in Connecticut as new farms spring to life.

The English Barn

The location of the barn on nearly every farm in Connecticut was, of course, well within sight of the farmhouse—yet far enough away to ensure that a fire in one building would not bring down the other. Farmers wanted to be able to see and hear what was going on at the barn throughout the day and night, since being able to sense trouble brewing was critical to staving off problems before they grew too large. When possible, barns were also situated to catch the greatest amount of the sun's light and warmth during its track across the sky. Hard-working farmers appreciated any available comforts.

The floor plan for the barn was fixed by tradition. These early barns were so similar in size and layout that they are known today

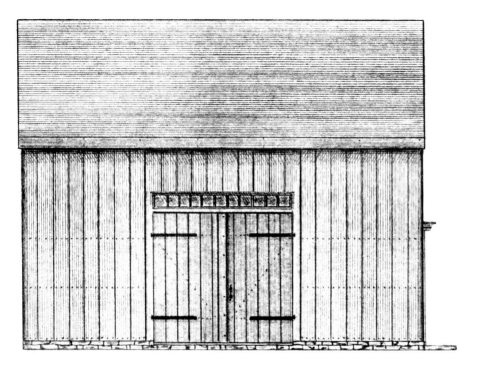

Early English barn.

its being the correct size and shape necessary for their survival. Much like evolution in animal and plant life, the English barn progressed to become an intelligent answer to a particular problem.

The English barn was a gable-ended structure with the major doorway on the long side of the building beneath the eaves. These barns often had a pair of large doors on both sides of the building, which allowed wagons to pass directly through. While the large doorways provided much-needed light and air during warm summers, in winter months smaller entryways made more sense. Small doors were often built into larger doors. Given the precious nature of glass at this time, barns were built without windows. When the doors were closed, the only light penetrating the gloom would have come from gaps between the planking of the exterior siding. In the winter, barn interiors were quite cold, being able to elevate outdoor temperatures only slightly, but this was enough to keep farm animals alive.

The three bays of the barn were often quite open, from the ground level on up to the roof's ridgeline. The center bay of the barn was generally left clear to allow

as 30x40s. That is, they generally measure out to be something near thirty feet wide and forty feet long. The timber frames for these buildings divide the structure into three distinct bays, or sections. While there is some variation from barn to barn, it is astonishing to modern eyes to see just how little. Before settlers even considered crossing the Atlantic, hundreds of years of structural evolution had refined the barn to the point where a family could depend on

for the passage of wagons. A tightly laid wooden floor was common in this area of the barn, as grains such as wheat and oats were threshed here before the advent of mechanical threshers. To separate the seeds from the rest of the plant, workers placed grasses on this floor and beat them with flails. Wind blowing through the open doors of the barn would waft away the chaff—the unusable portion of the plant—as the seeds were tossed into the air. Once separated from the chaff, the seeds were collected and stored.

The center bay also provided a working space sheltered from the weather for whatever purpose may have been needed: the repair or building of equipment, animal husbandry, or the thousand other tasks related to daily life. The bays to either side of this central bay were used to store grasses and other crops or to house farm animals. Except for the animal stalls, these bays were kept open to the rafters, rather than being divided into rooms. These two bays, at least early on, generally had simple dirt floors. While economics may have played a role in that decision, it was also more practical to have earthen floors where animals were penned. Wooden floors covering the entire

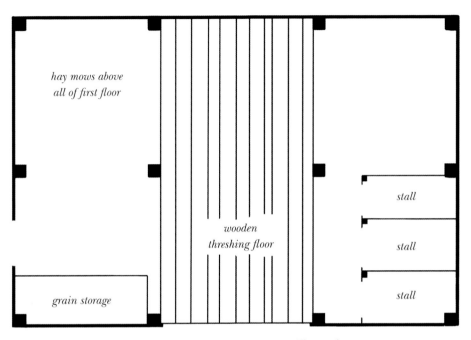

Floor plan.

first floor of the barn became necessary, of course, with the advent of cellars.

In early New England, farmers might keep sheep, cows, pigs, chickens, oxen, or horses. These were animals that could withstand the winter temperatures if kept out of biting winds and falling rain or snow. Their wooden stalls were built to accommodate them over the harshest months. The pens kept the animals separated from the grasses and grains stored around them, and encouraged huddling for added warmth.

Differences between Early Barn and Early House Construction

The skills and framing techniques a carpenter used to build barns and homes were much the same; there were few significant differences between the two. Of course the daily operations taking place within the barn were quite different from those taking place within the home, leading to differences in interior layout. The barn, in contrast to the home, was an open and airy structure. Since timber-framed structures are self-supporting—that is to say, they do not depend on sheathed walls for stability, as modern buildings do—a timber-framed structure can be left entirely open without fear of collapse. For grass-crop storage, voluminous space was required, and farmers knew well the importance of air circulation. Grass crops are subject to mildew and rot if not thoroughly dried, and imperfectly dried grasses can spontaneously combust—something settlers could ill afford. Additionally, dried grasses were not pressed into neat rectangular bales as they are today. Rather, they were stored loosely as they were cut and placed in the barn by pitchfork. Open spaces allowed for easier pitching.

The Connecticut farmhouse had a different role to play. Beyond being a place to eat and sleep, the home was also a workshop where essential tasks were performed. Foods were cooked and preserved, wool was spun and made into clothing, and products were made to trade for necessities not available on the farm. While, like the barn, the home's primary function was to keep its inhabitants warm and safe, it needed to do a better job of it. Open and lofted spaces are treasured in today's homes, but such large volumes of air were impossible to warm with the primitive heating systems available at the time. Unlike the barn's occupants, the inhabitants of the home couldn't weather the temperatures of the winter months without being a little more snug. Planking on the sides of their homes was itself sheathed with either split wooden shingles or riven clapboards. Interior walls were plastered as a further measure against drafts. Rooms within early houses tended to be smaller than the rooms we live in today. Low ceilings helped to keep rooms warm by reducing the volume of air. While New England's homes were certainly quite cold

by modern standards, fireplaces and eventually more efficient woodstoves kept the family moderately comfortable by burning first wood and, later on, coal.

Unlike domestic structures, barns had no requirements for uniform floor levels between sections. They could be at one height or any other—practicality determined the particulars for each working level. In early barn layout and construction, form strictly followed function in an attempt to make the work within the barn's walls as efficient as possible. The needs of the farm and the farmer took precedence over other considerations. Because everything today is strictly ordered and governed by building codes, floor levels in old barns often seem randomly placed to our modern eyes. We do not expect to bang our heads on timbers or fall through openings as we walk through a building. In a working barn, however, modern safety regulations would have been a hindrance and dramatically reduced efficiency. A particular farmer might have specified a height to the mow, or hayloft, because he knew how high he swung his pitchfork from the ground or from atop his wagon.

The requirements were different for the ends of the barn, in which the animals were housed. The second floor height might start slightly above the maximum height of the animal intended to live there. The flooring above an oxen stall, for example, would be higher than the flooring above the sheep. Keeping floor heights at a minimum above stalls not only made better use of the available space but also added the benefit of keeping the animals warmer in winter. To decide arbitrarily that the second floor should always start, say, at eight feet would waste valuable barn space. When one's survival is at stake, decisions are generally made for very practical reasons.

In addition to varying floor heights, irregular construction is also seen in barn lofts, which did not need to be built as permanent structures. Unlike the second floor of the home in which the family lived and worked, where solid footing underneath was essential, barns were built with flexibility in mind. Many farmers used temporary flooring to store summer harvests. Rather than framing the lofts with full floor joists and covering them with solid decking to make a loft floor, they often employed poles made from saplings to span the distance between girts (supports

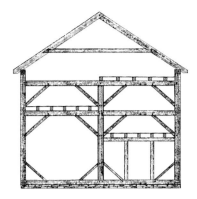

Floor heights often vary in older barns.

7

that run horizontally from post to post). Enough loose boards were placed across this quick joist system to allow farmers to load the ever-rising pile of hay. Less expensive to build, this system allowed for better crop ventilation and added flexibility should the volume of any particular crop vary—although the arrangement certainly made working on top of them all the more interesting. Temporary floors were simply placed where desired and as necessity dictated. Additionally, this loose arrangement allowed farmers to take full advantage of the volume of dry space available. If you imagine trying to pitch loose hay into a room with a fixed ceiling, it isn't hard to see that the ceiling will quickly get in the way of the work. If, however, you pitch the hay as high as you can and then put the ceiling into place, the work becomes much easier. Much later, farmers invented an overhead trolley system running the length of the barn. A large pair of tongs, or horse forks as they were called, hung from this trolley by block and tackle. The forks could be lowered to pick up huge loads of loose hay from a wagon, then raised to any level and dumped onto mows where desired. Here again, having an open structure was

essential. Even later, some farmers built barns into hillsides, which allowed them to drive their wagons in near the top of the barn. They simply tossed the hay downward to fill the mow, eliminating much of the physical effort. With the invention, well into the twentieth century, of hay balers priced for the small farm, permanent floors were often added to older barns or built into new structures, since uniformly shaped bales ended the need for open lofts.

Materials Used to Construct Timber-Framed Barns

The earliest barns were, by necessity, constructed of timbers hewn entirely by hand. In fact, hewn timbers would remain the standard well into the 1800s, depending upon location. Even as water-powered saw mills began to dot the landscape, the frame's heavy timber was generally hewn into rectangular form by hand—for both economic and logistical reasons. It took simply too much effort to transport heavy logs to distant mills for the four cuts needed to transform them into rectangular forms, before then shipping them back to the building site. Given the weights involved, and the need to move logs with

animal power over primitive roads, hewing a timber on the spot and moving it just once to the building's location saved labor overall. This would remain the case until the advent of balloon construction, in which buildings were made entirely of sawn timber. As one might expect, sawn timber began to make its way into timber-framed barns as saw mills opened throughout New England. Smaller timbers used in the frame, such as wind braces, joists, and eventually common rafters, were the first to replace pieces once hewn. Despite the spread of mills, carpenters preferred to use hewn timbers right into the late nineteenth century.

Until water-powered saw mills could be built locally, planking used for siding, flooring, or as roofers on the barn was ripped by hand. These boards were sawn from logs by what were known as pit saws. Logs were placed on scaffolding, or above a pit dug into the earth. This setup allowed sawyers to use a long, two-handled saw. A person standing on top of the log would both guide the saw blade and pull up, while the person below pulled the blade back down. Together, they ripped the log into planks. As can be imagined, this was a long

and laborious task, and another reason why flooring was not used unless entirely necessary. Although water-powered mills with gangs of saw blades eventually took this job out of the pit, planks nevertheless continued to represent a serious financial investment.

The construction of saw mills was an important advancement for any village, as it allowed for the provision of the most essential raw material of the time: lumber. These mills were, of course, more likely to be built along the coast, with its greater population and ready access to materials from abroad.

While the milling of lumber represented a significant expense, the raw materials were quite common, and thus relatively inexpensive. For early settlers in Connecticut and throughout New England, trees were plentiful. Additionally, wood is one of our most versatile materials. It can be used in countless ways. Beyond the construction of barns and homes, wood appeared in nearly every aspect of a settler's life: furniture, bridges, wagons, ships, barrels, fences, tools, and, later, at least in myth, even George Washington's teeth.

As a construction material, wood in early New England had no equal. In fact,

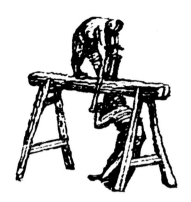

Using a pit saw. Bruegel, *Prudentia*, 1559.

wood remained the most important building material in this country until the widespread use of materials such as steel, aluminum, and concrete in the twentieth century. The differing properties of wood from various tree species were put to use in numberless ways. Oaks, being dense and strong, were used to build timber-framed houses, barns, bridges, ships, and equipment that underwent hard use. The conifers found in New England provided a relatively lightweight material once dried—a material that also maintains a high strength to weight ratio. Conifers offered settlers wood that could be used in furniture, flooring, siding, masts, and any number of smaller objects. Effortlessly sawn, quick to season, and easily worked with hand tools, softwoods were also milled into lumber used to make doors, windows, clapboards, and trim. Highly rot resistant black locust was useful for fence posts, and its high tensile strength lent itself well for use in trunnels, the wooden pegs used to fasten timbers together. White cedar, because it is easily worked, weathers well, and swells quickly when dampened, made the best shingles for roofing and siding. Ash and hickory were used as tool handles or in the making of the tool itself. Settlers heated their homes with wood, cooked their food above it, and transported their goods in it. Despite today's variety and availability of materials, we still largely depend on wood for many of the same things. Steel and aluminum are too expensive for home construction, and who among us doesn't prefer wooden furniture to plastic? Even the humble wooden shipping crate is lovingly polished and elevated to the status of furniture.

Although certain woods were preferred for specific jobs, every wood imaginable was used in barn construction. Oak was the ideal material for barn framework, given its strength. In general, softwoods were desired for planking stock, as they were light in weight and dried quickly after sawing. Clapboards and shingles were generally made of pine or white cedar. But that said, every one of these materials can be found doing any one of these jobs in New England barns. As time went by and forests disappeared, framers became less finicky about the materials they used. If one type of wood was not available locally, another was substituted. If a stand of pine covered the land upon which the barn was to be

constructed, more likely than not the barn was made of pine. There was a beautiful barn in New London, Connecticut, that was framed entirely with black locust. Unfortunately, arsonists demolished it early in the twenty-first century. Connecticut barns are framed with pine, hemlock, chestnut, elm, oaks of all types—and I even found one with timbers of walnut. Unlike today, when materials may be gathered and delivered from locations thousands of miles distant, colonial builders shopped locally, and the nearest tree was often the best tree for the job.

The timber-framing tradition that colonists brought with them to Connecticut had been around for centuries, and with few changes it would last nearly two centuries more. There were two primary reasons for this: the cost of sawn lumber and the cost of iron nails. For early builders, lumber in the form of planks or timber represented a significant cost in both time and labor. Even if sawn by a mill, these boards had to be purchased with either cash or tradable goods. In agrarian societies, cash and the time needed to produce goods beyond those required by the family were often in short supply. Any construction method

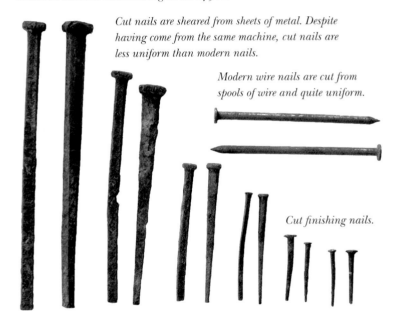

Lathe-turned trunnel. Note tapered end of trunnel is unusual for most barns. This trunnel was turned for a Shaker barn, thus the refinement. As the holes bored for trunnels were not tapered, blunt ends were generally used.

5.5-inch heavy framing nails down to 1-inch finish nails used to fasten trim. Machines cut these nails starting in the 1790s.

Cut nails are sheared from sheets of metal. Despite having come from the same machine, cut nails are less uniform than modern nails.

Modern wire nails are cut from spools of wire and quite uniform.

Cut finishing nails.

that reduced the number of components that needed to be paid for was usually preferred.

Iron nails were the second limiting factor in barn construction. Nails were very dear in the New World and were used sparingly. While iron, copper, and bronze nails had been around for centuries, they were expensive to make. After ores were found and dug from the earth, they had to be put through the smelting process just to produce base metals—and the smelting process itself took a tremendous amount of energy. It is not hard to imagine the prohibitive cost of heating iron ores to temperatures upward of 2,700 degrees using charcoal as fuel. After the first steps, of simply producing base metals, the nails themselves had to be forged by hand. Making nails from raw stock, one at a time, discouraged frivolous use. Nails were used only when nothing else would do.

It wasn't until the early 1800s that the price of iron began to drop as furnaces reducing these ores became more efficient. Changes in technology allowed for higher and more consistent temperatures, and the switch to high-energy coal in the smelting process began to make a difference.

The first nail-making machines to cut nails from iron sheets were invented in the 1790s. They eventually replaced the need for blacksmiths to forge nails one by one. Despite these changes, the cost of nails remained a limiting factor, and timber framing remained the dominant technology throughout most of Connecticut until after the Civil War, when nails became relatively inexpensive.

The first significant innovation in home and barn construction came, as previously mentioned, with balloon frame construction, the forerunner of the building system we use today for most domestic architecture. In balloon framing, relatively light pieces of wood are joined with inexpensive metal fastenings using comparatively unskilled labor. Rather than laboriously cutting mortise and tenon joints, workers simply cut the wood to the appropriate lengths and nail the pieces together. While there were hundreds of individual pieces that went into the frame of the building, each piece was light in weight and came from a mill ready to use. Signs of what was to come with balloon framing began quite early in cities, where the need for housing was great, but it wasn't until after the Civil

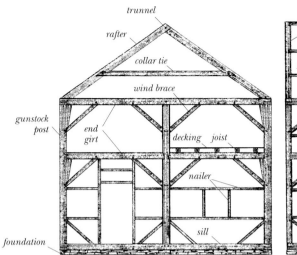

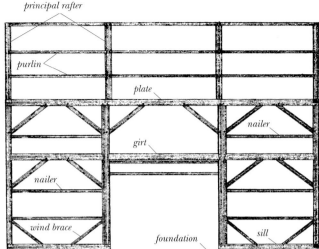

Timber framing.

War that this framing method became the new standard.

Balloon framing eventually ran its course as well. Because of several distinct disadvantages to the technique, it was replaced with today's system of framing: platform construction. In platform framing, an eight-foot wall is erected and the next floor is built on top of it. This allows carpenters to build the second floor's walls on that deck. In balloon framing, walls run the full height of the structure, often two or three floors, forcing carpenters to work high in the air. Much longer pieces of wood are required in balloon framing,

potentially raising costs. Finally, balloon-framed buildings—up until the addition of fire stops—burned quite rapidly when they caught fire, an obvious hazard. While the timber framing tradition was generally wholly replaced by the late 1800s, there were some exceptions. There is a timber-framed barn on a farm just down the street from where I live that was built by the owner's father in 1917. Except for the fact that the timbers were sawn and not hewn, the barn looks as though it could have been built any time over the previous hundred years.

Despite the cost of metal fastenings,

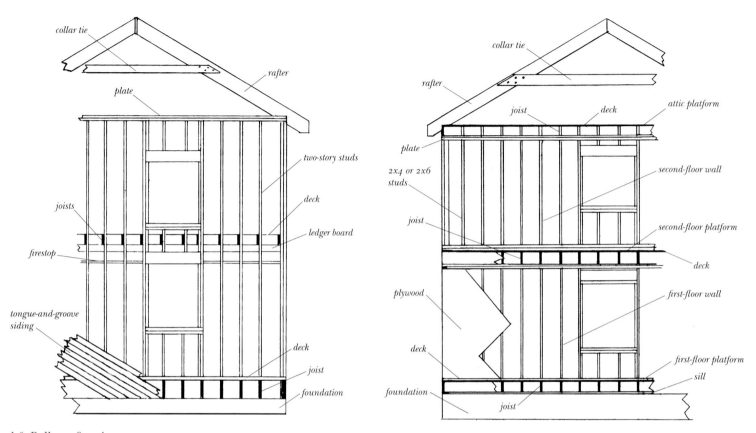

left: Balloon framing.
right: Platform framing.

planking used for siding on Connecticut barns had to be nailed into place. Trunnels, or the wooden nails that held the timber-frame portion of the barn together, could not be used to hold the relatively thin planks. Trunnels can be used only when the piece being fastened is quite thick—generally over three inches. Less than this and wood's seasonal swelling and shrinking will cause the plank to work its way off the trunnel.

Eventually, wood formed the roofs of most barns in Connecticut; but as previously mentioned, early records show that

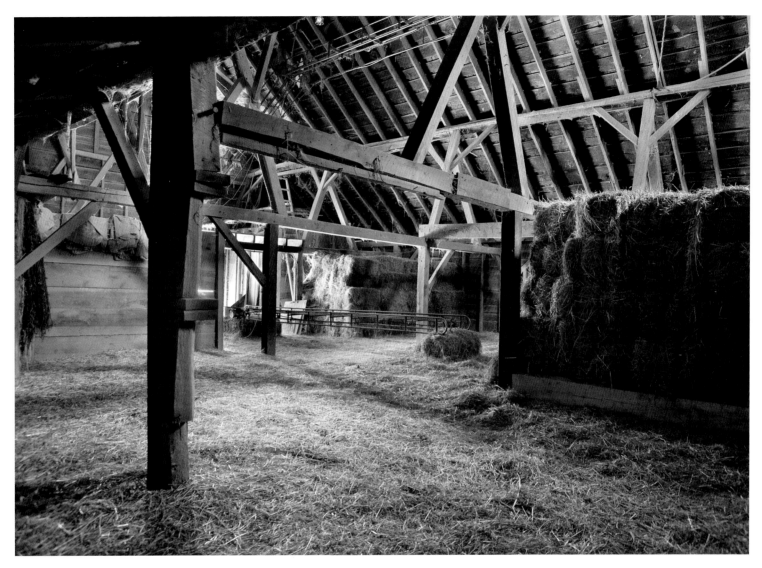

Although built in 1917, this timber-framed barn was constructed using time-honed techniques that would not have been out of place a hundred years earlier.

thatched roofs were used to a limited extent by the first settlers. They came from a thatch tradition and, to their advantage, this type of roofing required no iron fastenings. Additionally, the materials for thatching could be gathered by anyone with the time to do so, as no skill was needed to gather reeds. Thatching, however, had its problems, especially in the harsher New England winters. Wooden shingles formed a more durable cover in Connecticut and became the standard roofing material for nearly all buildings in the state.

The one constraint not faced by colonists was a lack of materials. They enjoyed a seemingly endless supply of timber. While most of England had been stripped of its woodlots by the seventeenth century, America's forests stretched far beyond the settlers' ability to comprehend. Building materials were here in vast quantities. Where elaborate joinery was sometimes used in England to overcome the shortage or quality of materials, New England provided early builders with no such restrictions. With so much wood available to them, at least early on, joinery could change to take advantage of that wealth.

Timbers running the length of the barn in one piece were the norm, eliminating much of the joinery needed in European barns. Forests were cleared, homes, barns, and villages were built, and colonists began their sweep across the continent with little thought given to sustainability. Although at first the supply of timber must have felt infinite, by the mid-1800s Americans had reduced nearly 60 percent of New England's forests to open fields. It is not uncommon to find photographs at local historical societies showing their town and surrounding landscape devoid of trees.

Constructing a Timber-Framed Barn

As with the start of construction for any modern building, the foundation for the barn came first, although work on the timber portion of the structure might begin simultaneously. Given the low cost and ready access to stone throughout the state, Connecticut barns were most often placed on foundations of that material. Depending upon the topography of the owner's land, the barn could be situated in a variety of ways. As mentioned, barns were generally located as close to the farmhouse as was

convenient; even today's farmers like to see their barn from the house.

If the barn were to be placed on perfectly flat land it was usually built without a cellar. Trenches were dug below the frost line, and foundation stones were put into place and backfilled. Nearly all of the earliest barns were built on flat land. Much later, if the terrain allowed, foundations were cut into hillsides to allow for cellars. For colonists, mortar was both expensive and unnecessary, and stone foundations for barns were generally of dry construction. Where cost was a concern—and in general it was—they used rough stone from the fields. In other cases quarried and dressed stone was used, with the advantages that longer pieces of regularly sided material brought. That was seldom the case in early barn construction, when quarries were few and far between and time was better spent on other tasks.

Eventually the use of mortar in foundation walls became more common as the cost fell. Mortar not only made for a more permanent wall but also eliminated many of the cold drafts piercing the barn in long New England winters. In many cases, foundations that had been dry-laid when built

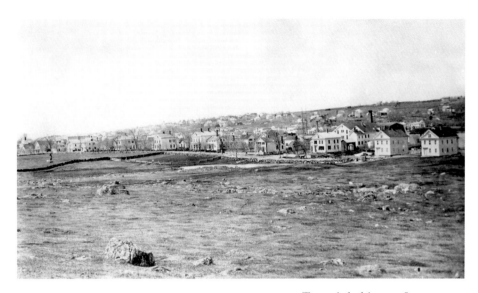

were simply pointed or parged with mortar to eliminate drafts. Mortared walls were replaced in turn either by walls built with concrete blocks or by continuously poured concrete walls, as is common today. As ever, cost and availability drive these considerations, and builders continued to construct working barns atop stone foundations into the twentieth century.

Once the foundation had been excavated and constructed, work on the timber portion of the barn would begin. Timber was felled, hewn, and transported to the site. While in general experienced carpenters built most barns, property owners

To an inhabitant of Connecticut in the twenty-first century, this landscape seems curiously barren without trees. Photo from the Stinson Collection, courtesy of Mystic River Historical Society, Inc., Mystic, Connecticut.

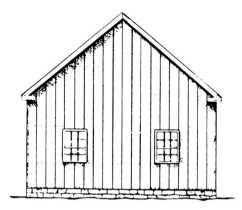

A barn built on flat ground compared with a barn built on a foundational cellar.

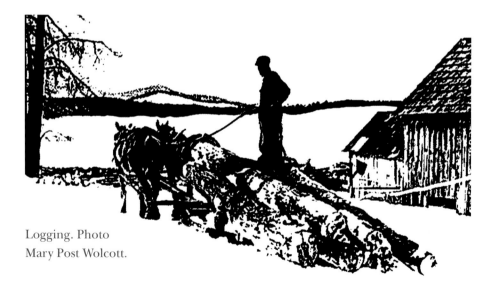

Logging. Photo Mary Post Wolcott.

with skills and time could save money by doing parts of the job themselves. With no fieldwork to do in winter, farmers could work on new tasks. Felling, hewing, and transporting timber back to the farm saved some of the cost of having the barn built. In early New England, much of the logging work was done in winter. Not only were farm operations curtailed then, but, more important, transporting heavy loads was easier by using sleds on snow-packed roads. It is still possible to find elderly farmers who remember spending time in the woods with their horses and sleds hauling timber during the cold winter months.

Several types of ax were used for hewing. The felling ax, of course, began the work of turning trees into timber. As mentioned, trees were hewn into rectangular shapes where they were felled. This lightened the work of transporting them by removing a significant amount of weight. When a housewright hewed an 8x10–inch timber from a tree, some 37 percent of the tree could be left behind. By hewing trees where they fell, the barn builder reduced wagon-loads by a third and made for easier lifting. A twenty-four-foot, freshly hewn 8x10–inch timber of white oak weighs more than 850

pounds—difficult enough to move. Before hewing, it would have weighed nearly three hundred pounds more.

To hew a timber into a square or rectangular shape, both the felling ax and a broadax (or hewing ax) were used. The felling ax has a knife edge: it is sharpened on both sides, with the cutting edge centered in the thickness of the ax head. The hewing ax, on the other hand, is sharpened with a chisel edge. That is to say, one side of the ax is left flat, and the other is ground down to meet it in a cutting edge like that of a chisel. The flat side of the ax is what shapes the flat surfaces of the timber. Whereas the handle on a felling ax is straight, the handle of the broadax is bent into an offset to allow room for hewer's hands to pass by the timber in order to slice wood from it.

To begin with, the hewer sets the log upon stands, or wooden horses, at a convenient working height—generally about waist high. The anticipated shape of the finished timber is drawn on each end of the tree, making sure that the lines of the rectangular shape desired are either plumb or horizontal. String runs the length of the timber and connects the corners of the rectangles on either end. This allows

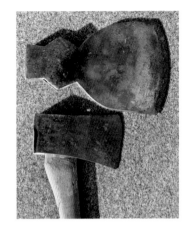

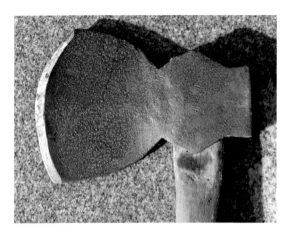

top, left: Felling axes.
top, right: Hewing or broadax.
left: Adze.

the hewer to visualize the edges of the flat surface to be hewn within the round and irregularly shaped tree. The felling ax is then used to chop deep cuts across the log and between the two strings. These chop

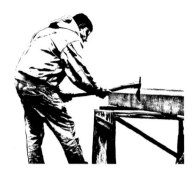

Using an adze.

cuts are spaced roughly six inches apart down the entire length of the timber. Such cross-grain cuts allow the hewing ax to split pieces off the tree without getting stuck in the long grain of the wood. In this way the hewer does not have to split off a piece the length of the timber, but rather can simply slice off six-inch pieces. After the cross-cuts have been made, the timber is generally rotated 90 degrees. This allows the person hewing to stand with his left side against the timber and swing the broadax vertically down to hew off the material between the six-inch cross-cuts. The offset handle on the ax keeps the hewer's left hand from hitting the log. If you look closely at a hewn timber, you will see these cross-grain cuts, as well as the divots from which pieces were sliced.

Depending upon the skill of hewer and the care expended, the finished surface might be left very rough or quite smooth. Barn frames, in general, did not have the finish usually found in homes of the same period. If the timber in a home was exposed, it was often highly finished. While that does occur in some barn frames as well, it is less common. Speed of construction and utility were the norm, although

the roughly finished surface is still beautiful by modern standards. In rare cases, one more finishing tool was used—an adze.

The adze, which looks like a hoe and is often mistaken for one, is another chisel-edged tool used to finish timbers after the ax work is complete. As with the hewing ax, this tool is used to cut across the grain—but with much more control than is generally possible with an ax. The adze removes the roughness left by the broadax and can, in the hands of a skilled carpenter, remove paper-thin shavings of wood. I have often wondered if it is possible to distinguish between timbers hewn by specialists, who did it for a living, and those hewn by farmers to save money. Those who hewed timber day in and day out became incredibly skilled, leaving an extraordinary finish on some barn frames. While most farmers could manage an ax to one degree or another, their work would undoubtedly seem less refined.

One common misconception is that timber used to frame homes and barns was seasoned before it was worked. In the days of hand tools, that was simply not the case. Timber for barns, houses, or ships was always worked green. In fact, dried timber

would have been nearly impossible to hew. Beyond the increased difficulty of working dried wood, few people could wait a dozen years or more for timber to season. An 8 x 10–inch white oak timber, left to air dry, will dry at a rate of about a half-inch per year. As a consequence, timbers cut and hewn would simply dry after placement. This was only true, however, for heavy timber used to frame the barn. The rest of the materials for the structure had to dry before they were put to use. While it didn't matter that a timber would shrink as it dried, it was important that flooring, siding, doors, trim, and the like did not. Boards made of white pine could air dry in the summer over the course of a few months, eliminating most of the problems shrinkage caused. Because of this, boards were sawn in advance and allowed to dry long before they were needed. Note, however, that builders cut the planking stock from green timber for the same reason: green wood is simply easier to work.

Once the timber for the structure had been hewn to the sizes required and transported, the joining of the frame began. Early barn framers used joinery to connect heavy timbers into a solid, freestanding

structure. The type of joint cut where timbers intersected varied, depending upon the job the joint had to perform, each type of joint having its strengths and weaknesses. As with all trades and skills, joinery was learned and passed down through a guild system by generations of carpenters to their apprentices.

Secrecy was as important in the timber-framing guilds as it was in other professional trades of the time. Livelihoods depended on skills being closely guarded and passed down only to trusted individuals—a knowledge gleaned over hundreds of years of experience. Housewrights of the time seldom experimented with bold

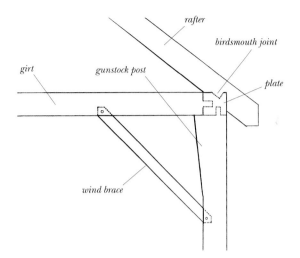

Gunstock joinery.

green wood – wood that has been recently cut and therefore has not had the opportunity to season or dry by evaporation of the internal moisture

Joinery – Mortise and tenon for posts, beam, WB.

Birds mouth joiney for rafters at bottom

21

new ideas or risked their reputations on untested theories. While this led to a rather halting pace of change, it seldom caused disaster: barns did not collapse from bad engineering, and once in a while a new, time-saving trick or two caught on.

While there have been definite evolutionary trends in barn framing over the course of centuries, historians still have to be cautious in guessing a barn's age simply by the type of joinery used. A young man apprenticed to an elderly barn framer could be learning techniques that had been in use some fifty or sixty years before. Fifty years later, the once-young apprentice might pass those techniques to his own apprentice, and in that way a newly framed barn could be nearly indistinguishable from a barn framed a hundred years earlier. Additionally, the reuse of materials might throw dates into question. Given the time and labor it takes to create timbers, those still usable were (and still are) repurposed when a building came down. Such timbers were often incorporated into new buildings. While in many cases they are easy to spot, based on differences in size, the way they were hewn, or by joinery where other timbers don't intersect, researchers

still have to be careful. Because of the deep resistance to change and our ancestors' penchant for adaptive reuse, other factors can more reliably gauge the age of a barn. The type of nail used in the barn's construction or original architectural details generally offer a more reliable way to place the structure in time.

The conservative nature of American carpenters is well illustrated by the introduction of builders' manuals, such as Asher Benjamin's 1827 *American Builder's Companion.* Articles there discuss the concept of wooden truss design, which offered carpenters a means of free-spanning large open spaces while using a minimum of materials. These trusses were generally aimed at the needs of large public buildings, such as churches or meeting halls, and timber framers in early New England approached their use cautiously. The need to place a post every fourteen or so feet to support the load above, in traditional timber framing practice, could have disappeared had carpenters trusted the engineering they saw in these books. At first, carpenters embraced the use of trusses without any belief in what they could do or understanding of how they worked. Rather than ignore

the truss entirely, they used them with unnecessary caution. Where trusses could be built with relatively lightweight materials, framers kept the size of the timbers similar to what they had always used. Where trusses could span the width of a church and fully support the loads imposed, carpenters built trusses but kept posts beneath them as a precaution. When architect and builder Ithiel Town designed the First Church of Christ in New Haven, he was able to free-span nearly seventy feet with light pine trusses. Meanwhile, rural barn builders still felt uncomfortable spanning thirty feet with enormous trusses made of oak.

The basic building block for a timber-framed structure is the "bent." Each bent assumes the form of a typical cross-section of the building. If you were to remove all of the sheathing on the gable end of a barn, you would be looking at the basic components of a bent. The bent is composed of posts running vertically, girts that run horizontally from post to post, and wind braces—that is, short pieces angled at 45 degrees that provide rigidity to the frame by running from the posts to the girts. Typically, posts may be anywhere

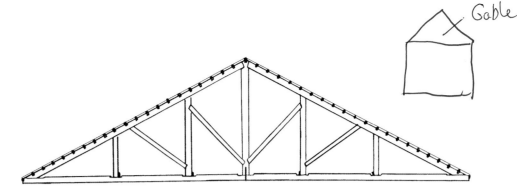

Truss from First Church of Christ, Congregational, New Haven, Connecticut. This truss spans nearly 80 feet with 6.5-inch-thick timbers.

from one to three stories tall and will have girts intersecting them at each story. The bottom ends of the posts rest on sills atop the foundation around the perimeter of the building, or on stone piers where the center posts land. Depending on the preferences of the builder, his training, and the loads to be carried, the girts may also form a simple truss as they cross the building. A bay is a section of barn between one bent and the next. Each bent is connected to the next for the length of the barn with plates at the top of the posts, upon which the rafters will land, and girts at each floor level in the barn. The bottoms of the posts are connected to each other through the sills. Small barns or sheds may not have had second floors, and posts will be connected only by plates and end girts. Most working barns had at least a second floor loft. Very large barns built much later may have two

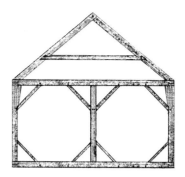

Bent for a small barn or shed.

or sometimes three separate lofts before reaching the level of the rafters, although that was generally not the case for early barns.

While they certainly shared many similarities, the framing used in barn construction and the framing used in house construction were not identical. This should not come as a surprise, as the two served very different functions. Superficial differences, such as the quality of the finish work, were one thing. More important, however, was the way in which girts and plates—those timbers connecting one bent to another—were joined to the posts. In home construction, it was important for all timbers at the height of the floor to be at the same elevation. This was because flooring within each room landed on top of them. That is more complicated in timber construction than it might first appear.

Since timbers in framed buildings were connected by joinery and not by metal fastenings, ample material was required at the post where they all met. Imagine the top of a corner post in a building where two timbers need to land, the plate along the front of the building and the girt from the end. The massive plate, carrying the

entire weight of the roof at the level of the eaves, requires sufficient bearing on top of the post to transfer its burden to the foundation. At the same time, the end girt, landing at the same location on top of the post, transfers the weight of the wall and one-quarter of the floor load of the room it helps to delineate. Below them, at the level of the second floor, the front or rear girts of the building meet the end girts at the corner posts. In order to create enough bearing surface for both timbers to land safely, the posts used in houses were flared at each level where these timbers met. Flared posts, known as gunstock posts, expanded the size of the post at each floor and created the necessary landing space. As may be imagined, flared posts at each floor level added a significant amount of work and increased the size of the timber needed to make each post. The reason for this complication in a house had to do with the flooring, which was nailed to the tops of the plates and girts for the attic floor, or to the tops of the front, back, and end girts at the level of the second floor.

The earliest barns in Connecticut did make use of gunstock posts, a practice that had remarkable staying power in some

locations. Eventually, however, many barn builders realized that this didn't have to be the case. There was no need for flooring to be flush with timbers around the entire structure, as barns were not finished as houses were. Most early barn builders, remember, installed impermanent second floors anyway; eventually they realized that they could save a lot of work, time, and wood by simply bringing the girts into the posts at a different height. While plates running the length of the structure and carrying the roof load still landed on top of the posts, girts crossing the building simply entered the posts one or two feet lower. This framing pattern is visible on the outside of most timber-framed barns. Look at the gable end of the building and you might notice that the siding runs from the foundation up to a point a few feet short of the eave height. The sheathing covering the rafter portion of the building is nailed on top of this lower sheathing and to the rafters. The end girt is located behind the spot where the upper and lower sheathing meet. For most barns still standing in the state, girts that land below the level of the plate are the norm, but, as always, there are many cases where tradition stubbornly

refused to change and barns were constructed with gunstock posts.

Timbers must be joined in precise ways when connected only by joinery. There are joints that work under compression and joints that work under tension, two very different engineering problems. Builders choose the joint for a given intersection because it handles the task assigned. Common joints, such as the mortise and tenon, could be used in certain places but not all. Dovetail joints could keep a frame from pulling apart. Shouldered joints, such as are found where a girt enters a post, allow a girt to meet the post and maintain enough bearing surface to support its load, while the tenon on the end of the girt allows it to be fastened to the post with trunnels. Birdsmouth joints keep the lower end of rafters in position on the plates, and scarf joints join timbers together end to end when longer timbers are not available.

All of this joinery was cut by hand with saws, chisels, planes, and drill bits. While floor joists in barns were pocketed into the first-floor timbers, just as they were in house construction, upper loft construction would have been simplified. Remember, joists or even saplings were laid on top of

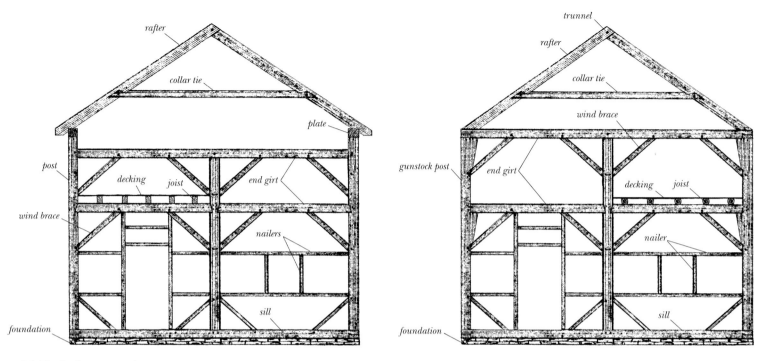

left: Typical cross-section or bent for a barn with end girt dropped below the level of the plates.

right: Typical bent for a barn with gunstock posts and upper girt at the level of the plates.

girts across these open spans to form temporary platforms. Beyond the savings in time, the strength of the beam on which these joists landed was maintained, because framers hadn't reduced the actual cross-section of the beam by cutting pockets. This in turn allowed smaller timbers to be used, again saving time, labor, and money.

As with most wood-frame construction techniques, including those used to build homes today, there is a piece of framing

that rests along top of the foundation called the sill. Today, sills support the weight above them uniformly along their length and are commonly made from material an inch and a half thick—generally a pressure-treated 2x6 or a 2x8. As they are continuously supported by a monolithic concrete wall, they do not have to be substantial in size. Importantly, they are highly rot resistant and keep the building materials above from contacting the foundation,

where they are likely to pick up moisture. The sills of a modern building do not tie the building together, although it may be argued that they keep it from sliding off the foundation.

In modern platform construction, small and uniformly manufactured pieces of wood are joined together with nails, and the loads they bear are distributed evenly among them. The loads of the entire structure are transmitted to the foundation equally around the entire perimeter of the building. That was not the case with timber-framed buildings. In general, twelve to sixteen posts carried the entire weight of the building above the first floor. (The weight of the first floor, if there was a floor, was carried directly by the framing of the floor to the foundation.) These posts all landed on the building's sills or on stone piers in the interior of the barn, and because of the loads they imparted and the type of foundations they rested on, sills functioned much differently than they do today.

In Connecticut's barns well into the 1900s, the sills in timber-framed structures were quite large and served three basic functions, all having to do with stability.

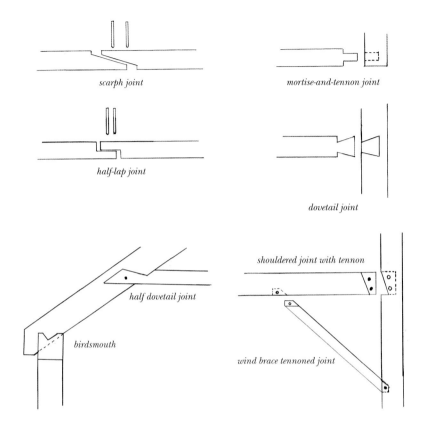

scarph joint

mortise-and-tennon joint

half-lap joint

dovetail joint

half dovetail joint

birdsmouth

shouldered joint with tennon

wind brace tennoned joint

Unlike modern sills, the sills in a timber-framed barn bear weight only where a post lands on top of them. There is essentially little or no weight placed upon them between posts. A one-inch-thick piece of oak will bear as much weight as an eight-inch-thick piece if it is resting on a continuous and even foundation. However,

timber framing depends strictly on joinery to keep it together, and for that heavy timbers are required. A heavy sill allows for a mortise to receive the tenon on the bottom of the post, linking the two pieces together. So the first function of the heavy sill is to allow for the use of joinery to tie the lower end of the structure together, keeping everything square and spaced appropriately.

A second function of the sill is to provide a nailing surface for the bottom edge of the siding that will cover the completed timber frame. The bottom of each vertical plank runs across the outside surface of the sill and is simply nailed to it. Additionally, siding boards generally extend down and past the sill a short distance, boxing in the stonework on the outside of the barn and further stabilizing the foundation wall. The third, and often overlooked, function of the sill is actually helping to hold the foundation together.

Early foundations were built like stone walls, with one stone placed on top of another. Without mortar to assist, gravity and friction alone must work to hold them together. It is quite easy, unless the stones are very large, to knock over sections of a stone wall by starting at the top. But if you were to place a large timber across the top of a level wall, the job becomes more difficult, so an important function of the sill is to help hold the foundation stones together in walls built without mortar. Because of frost and water movement within the earth surrounding foundations, barns built without cellars usually have fewer foundation problems. The exposed stonework may rise only one or two feet above grade, adding stability, and the wall below grade is firmly supported on both sides by earth. One disadvantage of barns with low foundations, however, is that they are more likely to rot along the sills because of their proximity to the moist earth.

Bank barns, those in which foundation walls are cut into hillsides and are backed by earth on only one side of the stonework, present new difficulties in construction. Despite the builder's best intentions, stones will eventually slip out of position over time, as the ground on the outside face of the foundation freezes and thaws. It isn't uncommon to see holes or buckling in stone foundations, which, some might be surprised to learn, seem to have little effect

on the structure's integrity. This is because the actual weight of the building is carried almost entirely on those limited number of posts. The rest of the foundation is doing little more than blocking out the weather or holding back earth. Problems for the structure of the barn begin when the stonework near or beneath the posts starts to give way. The sill helps to delay the inevitable shifting to which the foundation is prone.

Sills, once hewn square, were cut to length and joined. If the sills were long enough to run the span the building, no joinery was required along their length. If shorter pieces were used, scarf or lap joints were employed to connect them end to end. At each corner of the barn, another joint was used to connect the timbers at right angles. This could be a half-lapped joint, a dovetail joint, or even a simple mortise and tenon, depending on the training and preferences of the carpenter. Additionally, a mortise was generally cut through the corner joint to allow a tenon on the bottom of the post to further lock the two sills together. Mortises for intermediate posts down the length of the building were also cut at this time. Such smaller posts, not considered as structural as the major posts of each bent, were used for framing out the walls and supporting horizontal nailers between the major posts. Nailers provided a surface to which siding could be attached in the gaps between sills and girts, girts and plates, or plates and rafters.

If the barn required a wooden first floor, the sills would also receive pockets for joists. Joists are timbers running from one bent to the next, used to support the plank flooring. Joists could be hewn square like most of the other timbers in the barn, or, as was more often the case, left in the form of logs and hewn flat only on the upper surface. Beyond saving time, leaving the log round on bottom also left more material, increasing the strength of the individual timber. This is often the case with early rafters as well, where only the top surface is hewn flat. Also, it is not unusual to find the bark remaining on the first floor joists in barns and homes where only the top surface was worked. However, this is now considered poor practice, as it promotes insect damage.

Beetles, ants, and termites prefer to start their destructive work either in bark or in what is known as the "sapwood" of

a tree. Sapwood is the live portion of the tree—the only part of the tree that allows sap to run up and down the trunk. After this wood dies off and becomes heartwood in a living tree, it is much less susceptible to insect damage because of its hardness. A timber that has been hewn square has obviously had its bark removed, but most or all of the sapwood is cut off too. Leaving bark and sapwood on timbers encourages insects to make homes there soon after the trees are felled, and the damage they do is obvious to anyone looking at these timbers in old barns. While people generally believe the damage to have been done recently, that is often not the case. Unless there has been water damage, the rest of the timbers in the barn are generally not touched, because the bark and sapwood have been removed. Absent water damage, bugs will not attack dried heartwood. But of course, water damage usually does present problems, as in old barns maintenance of the siding and roof may have been neglected; when the wood becomes soft enough, insects will return to finish the job, bark or no.

Once the pockets or mortises for the ends of the joists have been cut, the joists themselves are cut and fitted. With the first floor or deck framing finished, the builder might put them into place and construct the entire first floor of the barn, if it is to have a wooden floor. This not only moves the material out of the way but also gives carpenters a platform upon which they can continue the work of cutting and assembling the rest of the frame.

The posts for the barn were generally cut next. Usually reaching to the eaves of the building, the tops of the posts would be flared in early barns to increase the landing for plates and girts. Mortises were cut for the wind braces and other timbers intersecting with them. Girts and plates traveling horizontally between the posts would then be cut and mortised as needed. When all of the components for each of the four bents were ready, they were assembled on the deck and trunneled together, ready to move into position.

The wind brace, the smallest component of the timber frame, plays a role much larger than its diminutive size suggests. Modern all-wood construction methods depend upon sheathing in sheet form to stabilize the building against racking. Plywood, chipboard, and other sheet

materials used today serve some of the same functions of the wind brace. The timber frame of a barn or house must resist not only the weights imposed upon them vertically—snow loads on the roof, or floor loads of hay, animals, and equipment—but side loading as well. Given their profiles—that is, as broad as a barn—they must be capable of withstanding the considerable racking force imposed by the wind. While vertical plank siding will help to reduce racking, it is no replacement for wind braces. This is the key to the strength of the trusses all around us—triangulation. Any piece of wood triangulating a structure adds strength far beyond what seems possible. Wind braces, running at 45-degree angles between major intersecting timbers, were tenoned and pegged into place to make the structure rigid. Many farmers have commented on their attempts to remove old barns: despite the fact that the timbers had significantly rotted and the structures were leaning at crazy angles, their tractors were unable to topple the walls until the wind braces were cut.

With the lower portion of the frame hewn and assembled, work could begin on roof framing. Roof framing in early

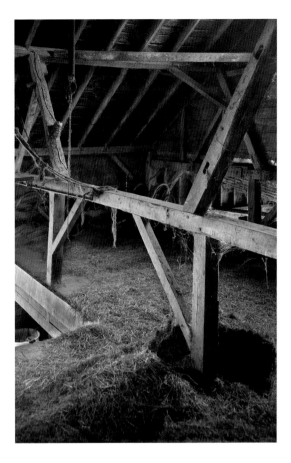

Wind braces.

Connecticut barns consisted of two distinctly different types. The earliest frames were based on what was known as a principal rafter system. This consisted of a handful of very large pairs of rafters spaced great distances apart. There could be as few as one rafter pair for each bent, or an

additional one or two more pairs in each bay between posts. The massive pairs were joined to each other longitudinally with timbers called purlins. Purlins were shorter pieces of timber of a smaller dimension pocketed into the rafters in such a way that their upper surfaces remained flush with the surface of the rafter. In this type of framing, roofing planks ran vertically up the roof structure, from the plates at the eaves of the building to the peak of the roof. Purlins supplied the required support for the roofing planks as well as the nailing surface needed to keep them in place. This system of framing evolved from that used with the earliest thatched roofs. In thatching, poles were lashed down the length of the building to the principal rafters. Thatching was lashed vertically to these poles. It was but a short step from poles to purlins and the next generation of roofing materials.

As time passed, however, the use of a common rafter system became more prevalent. This system, much like the one in use today, employed many more rafters closely spaced down the length of the building. Each rafter was identical to the last, and much smaller than the principal rafters of the earlier system. As there were no purlins used with common rafters, roofing boards ran the length of the building and were nailed directly into each rafter. Besides weighing less, there was much less joinery to fit in the common rafter system. We must assume that both time and money were saved with this type of framing, as it eventually replaced the older style entirely. It is possible to see the change from one style of framing to the next by inspecting transitional roofs from this period. Systems that retained principal rafters and filled in with smaller common rafters still exist. Again: slow and methodic change over time is reflected in this conservative approach.

With the foundation prepared, the entire frame cut, bents assembled, and perhaps the planking for the siding and the shingles for the roof on hand, the frame was ready for raising. While undoubtedly barns were often raised with help from the larger community, many were probably raised with just a few additional hands. Because this type of work is foreign to our lives, we often underestimate the feats our ancestors were able to accomplish. Regardless of who put them up, however, barns were generally raised in bents, despite the weights involved

in heavy timber construction. Having the bents assembled on the ground ensured the right fit. If slight modifications were necessary, they were more safely done on the ground than high above the deck. Each bent became a rigid assembly once it was fastened together, and it was constructed in such a location that the bottom ends of the posts were near their final resting positions. Given a bent's weight and height, barn builders did not want to raise and then have to move it. They initially began raising the bent into its vertical position by hand, then would employ pike poles to push the frame to its full vertical position after hefting the frame to the point where their arms no longer reached. Additionally, sets of block and tackle could be used opposite the people pushing to help with the task. Once the bent was raised vertically, temporary bracing was quickly attached to keep it in position. Acting like long wind braces, these diagonals were generally kept in place until the bents were joined together by their girts and plates or until the entire frame was assembled. The first bent raised was perhaps the most difficult, as tackle could be employed from a vantage point high on the first bent to help raise the rest.

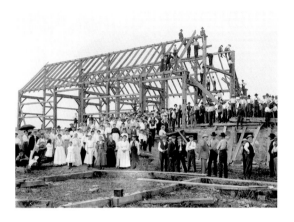

Barn raising. City of Toronto Archives, Fonds 1568, Item 177.

As each bent was raised and connected to the previous one, builders checked the structure to ensure it was both plumb and square before the joints were pegged with trunnels. Trunnels, generally an inch to an inch and a quarter in diameter, were made from hardwoods such as oak or black locust and were driven with a large wooden mallet known as a beetle. Carpenters had to bore holes through the timbers they were to fasten with trunnels, a chore unnecessary for iron nails. The primary advantage of a trunnel was that anyone could make them out of materials freely available. In general, the timber frame was connected entirely with joinery and trunnels, and this remained so even after metal fastenings became widely available.

Once the main portion of the barn was assembled up through the plates, builders could begin to raise the roof timbers. If possible, temporary planking was used to give the builders a place from which to work high up on the frame. This temporary planking could have been planks brought to the site for this purpose, or stacks of the material to be used later for roofers and siding. In general, rafters were put up in assembled pairs; once they were braced into vertical position, purlins joining them to the next pair could be installed. If a common rafter system was used, rafter pairs were simply joined to each other with a few boards and nails until they were all standing in position. As with the framing below, rafters were checked to ensure they were square across the building and plumb before the roof was sheathed.

With the rafters raised into position, the sheathing of the building could begin. Early on, with no other choices available to them, carpenters cut planks of wood and nailed them to the exterior of the frame to create the walls of the barn. Roofers, to which the shingles would be nailed, were installed, although unlike the siding below they were spaced apart to allow for air circulation under the shingles. Wooden roof shingles will rot very quickly if not allowed to breathe. While the roofing planks always got this final layer of sheathing, the sidewalls on early barns were most commonly left as planks. These boards expanded in humid weather and shrank in dry weather, allowing—for better or worse—both light and air to circulate freely through the barn.

As time and money allowed, additional siding materials might be added, not only as further protection from the weather but also to help seal cold winter drafts away from both livestock and people working in the barn. At various points in the barn's evolution, attempts were made to eliminate this free circulation of air. The siding itself could be joined along its vertical edges with either a tongue-and-groove or a ship-lapped joint to cut down on drafts; or the barn siding could be covered over with clapboards, shingles, or a second layer of vertical sheathing covering the seams. Some siding was simply seen as fashionable, and later barns were often sided and painted quite decoratively to show off a farm's prosperity. In the Victorian period, narrow battens were often used to cover the

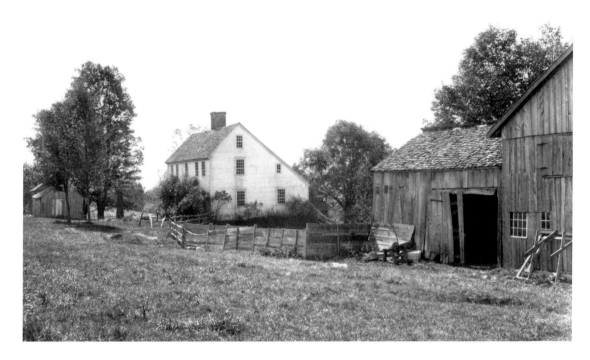

Saltbox and barn. The shed on the end of this barn has just been reshingled. The shingles on the ridgeline from the back of the roof have not yet been cut off. They will be cut flush, and ridge boards will be added to finish the job. Photo courtesy Barry Thorp.

seams of vertical planking. These battens were frequently molded into a decorative shape and painted a contrasting color to the barn, elevating the stature of the building. After the Industrial Revolution, other "novelty" sidings were introduced. These might consist of beaded matchboards or horizontal planks planed to look like clapboards and lapped to form a more airtight barrier. While wood was overwhelmingly the siding of choice for Connecticut's barns, a handful of barns were built with stone, brick, and eventually cinderblock, all of which required no other finish. In modern working barns, steel has often replaced wood entirely, allowing for enormous open spaces free of posts and interior walls.

The roof has always been the most difficult portion of a building to keep weather-tight, and, if not kept so, the most likely cause of a building's demise.

Barn with lights over main doorway.

Buildings with tight roofs can survive long periods of neglect, even with damaged exterior walls, but as many barns in Connecticut can attest, once the roof begins to go, a structure's fate is often sealed.

Experimentation with roofing materials in the search for less expensive and lower maintenance coverings led to the creation of many forms of roofing in the later part of the nineteenth century and throughout the twentieth. Slate roofs, while occasionally found on Connecticut barns, were far from common. In states such as Vermont, with access to high-quality slate deposits, barns were very often covered with this most durable material. Because it wasn't locally available and required slightly heavier framing to carry the extra load, its use was limited in Connecticut. As sheet metals became affordable in the form of galvanized iron and tin, copper, and eventually aluminum, they too were used to cover barns. Perhaps because of the noise they made during rainstorms or because they were closely associated with commercial structures, metal roofs are seldom found on older homes in the state, despite their snow-shedding ability. In contrast, the residents of Northern states such as Vermont, Maine, and New Hampshire quickly recognized this benefit and put metal roofs to good use on both their homes and their barns.

While most metal roofs consisted of long, overlapping sheets, various metals were also formed into shorter interlocking shingles, more closely mimicking the wooden shingles they replaced. This type of roofing, however, was not nearly as common as the sheet type, undoubtedly because of the extra installation labor required. The shingle dominating the building industry in the twentieth century was, of course, the asphalt shingle widely used today. Both inexpensive and easy to install, asphalt shingles are virtually maintenance free for a period of fifteen to twenty years. This roofing system eventually replaced the

wooden shingles covering most of the state's barns.

Spaces between siding boards in early barns did provide a nominal amount of light inside, but for real work to be done, the doors would generally have to be open. In the summer this posed few problems, but the winter months were a different matter. A 10x20–foot opening in winter was far from desirable. As glass became less expensive, windows were added to improve working conditions within the barn. Often these windows came in the form of transom lights, a single row of glass panes above the main doorway. Rather than open the main barn doors in the winter, smaller doorways allowed general access to the barn while minimizing heat loss. Windows high in the gable ends illuminated the lofts, and additional sash along eave or end walls helped to brighten the interior. As glass and large animals don't mix, sash was generally kept away from stall areas. While many windows were fixed in place, the addition of hinges or simple wooden tracks allowed them to open, providing ventilation and cooling in the summer months. As time went on and sash became less expensive, builders added more windows. Often

windows came from other structures as they were modernized or demolished, so it is not uncommon to find an assortment of types and styles in older barns. Still, there are many barns that never received windows at all; their walls remain as blank as the day they were built.

The Rise of the Bank Barn

The English, or 30x40, barns that had served farmers so well for hundreds of years would, of course, begin to change. At first these changes were based more on simple utility than alterations in farm life, yet these departures from tradition were subtle. Carpenters took advantage of abundant materials to eliminate unnecessary joinery. The gunstock post began to disappear and rafter systems became simpler. All of this occurred gradually in most areas of the state; and in general, isolated populations farthest from the coastline evolved at an even slower rate. The changes were minor, however, and the basic layout and design of the English barn remained the same right up through the early 1800s. Communities by that time had more than a hundred years behind them and were well established. People no longer faced

the harsh realities settlers had confronted, and the typical subsistence farm was more likely to have the wherewithal to weather financial ups and downs. Life throughout New England, however, was about to change in ways that could not have been predicted. The dawn of the Industrial Revolution would fundamentally change the way people had lived their lives for centuries. Barn designs also would begin to evolve in significant ways, a reflection of farmers' attempts to keep pace with the beginnings of the modern world.

As Connecticut towns and cities continued to grow, manufacturing became increasingly important to the overall economy of the state. Whereas nearly all of the initial settlers had operated as subsistence farmers, by the 1850s that was no longer the case. Many residents now worked off the farm and simply bought the things they needed with the money paid them from their new jobs, much as we do today. Because of this, the nature of farming itself began to change. Rather than making just enough for their own families, farmers, with the help of new technologies, began producing food for others. In the era of modern farming, a handful of farmers produced food for the many, and barn design evolved again.

One of the most noticeable advances came in the way barns were placed on the land. With some exceptions, barns had generally been built on flat ground up into the early 1800s. Realizing the need to keep barns as dry as possible, farmers built small berms to shed water away from the structures. While some barns were built with root cellars beneath them, the idea of a full cellar under the entire structure began to show up in the nineteenth century. Farms were beginning to grow in size, and farmers wanted to take advantage of the possibilities that banks or small hills provided in terms of construction. If the terrain suited, a barn could be built into a bank. The main doorway remained at grade level and the sides and rear of the barn could be raised in height as the topography fell away. These new structures gave farmers an additional room beneath the main floor of the barn, usually the length and width of the barn itself. This was also the most economical way to create added space, as the extra materials used in its creation were simply the stones needed to raise the foundation to the new height. As stones

were abundant, this added little cost to the overall project. Although cellars require excavation work, the natural slope of the terrain helped, and as the building above covered this new space, it was essentially roofed for free. These structures, which at first retained all of the other aspects of the English barn's design, are commonly known as bank barns.

Entry into early bank barns was along the eave wall, and the building's interior layout still consisted of three bays. Depending on the terrain, bank barns could have one, two, or even three walls of the foundation well out of the ground. Farmers would determine which walls would be solid and which would allow access to the cellar based on their needs. In many cases there were no solid walls beneath the barn, and stone piers held up the rear of the building. The floors of these open cellars were generally left as dirt, although in some cases they were covered with flat stone to keep stored materials and equipment dry or to make pulling wheeled equipment in and out easier. This space could also be used to pen animals in the summer months or to increase the overall stall space available on the farm throughout the year.

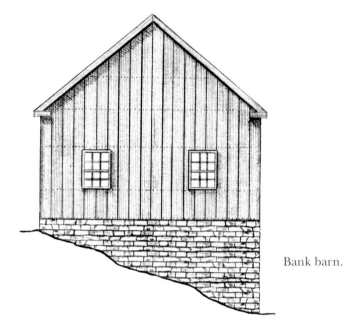

Bank barn.

Wooden walls, stone walls, or a combination of the two eventually enclosed this new space. With the addition of trap doors cut through the main floor, the cellar became a place to store manure over the winter. To reduce the day's labor further, manure could be dropped straight into a wagon waiting under the trap and taken to the fields as needed. If it were left to pile up under the barn during the winter months, farmers often penned pigs in the same area to work the pile down, saving themselves the effort. When families farmed for

themselves they typically owned just a few animals, and moving the manure wasn't an enormous task. When they began to feed others, however, the herds of animals they raised began to grow, as did the volume of animal by-products.

Subsistence farming, which the majority of the population had been engaged in up to the beginnings of the Industrial Revolution, kept soil depletion low. When individual families had but a handful of animals, the fields they tended were small and the manure produced was generally sufficient to maintain the soil. But changes happening concurrently throughout New England had a major effect on soil quality. Because of the stripping of the state's trees, for a host of economic reasons, rain was either washing away the fertile soils early settlers had enjoyed or burying it at the bottom of hillsides, since the forest's root systems no longer held it in place. When farmers began expanding their farms, the problem of soil depletion was exacerbated. Fields often grew larger as farmers planted crops to feed the cities and towns around them, but quite often the animal population on the farm remained the same or grew slowly in proportion. As many New

England farmers discovered, without manure to spread onto fields, soils quickly become exhausted.

Manure, although necessary for growing crops, can also be one of the endless problems with which farmers must deal. Even with today's level of mechanization, farmers spend a significant portion of their day coping with animal excrement. It has to be removed from barns, stored until needed, and then spread onto fields. In early barns, manure had to be shoveled out daily throughout the winter months, since the animals were penned inside. But leaving manure piled in the open throughout a long New England winter meant that many nutrients would simply wash away with the snow and rain. The new bank barns, aside from being easier to clean, also provided winter manure storage. Initially these cellars were largely open affairs, and fumes from the manure simply dispersed in the wind. As time went on, however, builders enclosed the area under the barn. Solid stone foundations with small entryways protected manure storage operations. Manure no longer washed away or froze, and farmers had an easier time spreading it on fields in early spring.

In solving the problem of lost nutrients, however, farmers had created new problems. It is not hard to imagine some of the consequences of storing large quantities of manure directly under livestock in the winter months. As doors could not be left open to ventilate the barn and rid it of the fumes generated below, animals were likely to fall ill. The drafty barns of the seventeenth and eighteenth centuries may not have trapped manure fumes, but by the nineteenth century barns had become tighter and their air quality more noxious.

As was well known, warm animals consume less feed in the winter, so farmers strove to keep their animals warm. To combat these new health and moisture problems without compromising warmth, ventilation systems were required. Cupolas, once reserved for grand public buildings or the homes of the very wealthy, began to appear on the ridges of barn roofs. While they did allow for some ventilation, they did not fully address the problems brought on by manure decomposing in the cellar. Finally, by the mid-1800s, farmers began to install ventilator shafts to air their cellars. Eventually, though, the cost of the battle proved too high, and farmers

abandoned indoor stockpiles. Manure was once again removed entirely from the barn. Bank barns continued to be built, but the cellar was used only to house animals or equipment. Ironically, the most modern barn designs in use today once again place manure below the herd.

Perhaps the only useful feature farmers lost with the advent of the bank barn was the ability to drive wagons straight through after unloading them, but that was certainly not an insurmountable problem. The next major evolution, which greatly reduced the number of new English barns built, came with the idea of entering the barn through the gable end. One disadvantage to entering on the long side of the barn and under the eaves had to do with weather. As gutters were nonexistent, both rain and snow loads from the roof fell directly in front of the doorway. While rain might be just a nuisance, snow was a different matter. In early barns the doors were large and swung outward from the barn. This meant that snow had to be cleared from the entire arc the doors traced as they were opened: another task to add to the daily list. While older barns were often refitted with exterior and in some cases interior rolling doors to

overcome this problem, another solution was to enter through the gable end of the building. There was still snow to remove at the gable end, but at least the entire roof was not shedding its load in front of the doorway.

As with eave-entry barns, gable-entry barns had a central aisle that allowed wagons of hay to reach the lofts. Another advantage of the gable-entry barn became apparent when farms outgrew their existing storage space. With these new designs, farmers could simply keep adding to the far end of the barn, as wagons loaded with hay could still reach them. While eave-entry barns were occasionally built throughout the nineteenth century, the new design's advantages made the gable-entry the clear choice for the future. Most barns built from the late nineteenth century onward would be gable-entry barns.

Connecticut Barns and the Industrial Revolution

The Industrial Revolution came to New England because of water. It was water, or more accurately, the power harnessed from fast-moving rivers and streams crisscrossing the Northern states, that caused the Industrial Revolution to blossom as it did in the Northeast. Without powerful waterways of their own, Southern states maintained an agricultural focus for a much longer time, a fact that would come to plague them during the Civil War. Connecticut's economy began to change from an agricultural base to a fully industrialized one starting in the early 1800s. People who left their farms for work in factories still required barns, but not the barns of their forefathers.

Barns built for people moving into the world of manufacturing reflected the change in the way they lived. They no longer derived their livelihood from farming. The horses they kept no longer pulled a plow but instead drove the family carriage. Their gardens became more decorative and less fruitful. Despite living in urban areas, however, most families still required a barn, albeit generally a much smaller one. Even as city dwellers, families may have kept cows, flocks of chickens, or pigs. If so, storage space was required. If the family owned a carriage, a place to store it and a horse stall were essential. The new barns these families built often looked like the new barns being built on farms,

but much smaller in scale. The Victorian era produced many lovely homes, and Victorian-era barns often matched the houses in character and detail. Books such as Downing's *Architecture of Country Houses* and contemporary periodicals that dealt with architecture or farming issues spread new designs and theories of barn construction.

Barns in developing towns began to reflect their owners' financial status, with architectural flourishes completely disconnected from function. The Industrial Revolution provided these flourishes, as woodworking mills began to churn out moldings, brackets, trim work, doors, and window sash in ever-increasing varieties. As the end of the nineteenth century approached life changed ever more swiftly, and Connecticut moved even further from its agrarian roots. This trend was to continue throughout all of New England in the twentieth century. At the end of World War II, there were nearly five thousand commercial dairy farms operating in Connecticut. By the turn of the twenty-first century there were fewer than two hundred, although the number of working farms in general is increasing.

As new barns in cities around the state

Victorian house and barn.

grew more decorative while shrinking in size and function, barns on working farms generally expanded while retaining their austere looks. Except for the new breed of gentlemen farmers building farm retreats in the countryside, frivolous details meant added expense and additional maintenance that the working farmer could do without. Their barns were changing in practical ways. These farmers were more concerned with expansion, and their barns

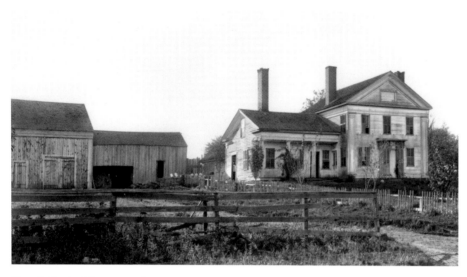

Greek Revival house and barn. Photo courtesy Barry Thorp.

cows were vastly different from barns built for vegetable farming. One specialty crop, tobacco, which at one point nearly covered the Connecticut River valley, gave rise to a completely new style of barn. While tobacco had always been grown in the state, first by Native Americans and then by European-settlers, it remained a relatively small industry until the mid-1800s. And while early tobacco barns were built to handle the particular needs of the crop, new barns reflected the large role the industry would play in state agriculture. Cigars became increasingly popular in the later part of the nineteenth century, and more and more farmland in the valley was converted to supply the demand.

grew in size—either with additions or with new construction around the old.

In factories around New England, specialization was key. Each industry produced one thing, and produced a lot of them. This same practice began to take root on farms around the state. Whereas subsistence farmers were generalists, producing many crops in the quantities needed by their families, farmers of the late nineteenth and the twentieth centuries began to specialize. They might have chosen to concentrate on one or two crops in particular, or they might have gone strictly into the dairy business. Barns built for milking

Nineteenth-century tobacco farmers air-dried leaves in highly specialized barns. Long, tall, and lightly constructed, the walls of tobacco sheds were built in such a way that many boards in the siding could be opened, allowing for greater ventilation to speed the drying process. The interior of the barn was filled with racks from which the leaves were hung. Tobacco fields would often contain row upon row of these huge structures, always an impressive sight. The industry itself was notorious for its ups and

downs in profitability, and the invention of synthetic cigar wrappers (made from scraps and stems of the leaf) in the late 1900s nearly finished off this type of farming. A small revival by purists demanding shade-grown tobacco wrappers pulled it once again from the grave, and there are still today small enclaves of these barns drying leaves in the north-central part of Connecticut. Although these barns dominated much of the countryside in the valley at one time, most have now disappeared, due in part to the light construction methods used to build them, their unsuitability for adaptive reuse, and the high cost of maintaining such imposing structures.

❦

Barns also changed as the dairy industry grew. Where one or two cows had been enough to meet an individual family's needs in times past, larger herds were now required if the farmer intended to earn his living through milk production for sale. Barns had to handle perhaps eighteen to thirty animals, and provide more space for milking and care as well. Barns began to be built to house herds of animals, not individuals. Along with the herds came new logistical problems. Vastly increased acreage was needed to feed these herds, and new storage spaces were required to hold the foodstuffs they would consume over the winter. The same concepts of industrialization used to increase production in mill towns were brought to bear on the farm, allowing farmers to work larger and larger quantities of land and handle larger and larger herds.

Perhaps the greatest change ever brought to farming came with the invention of the tractor at the dawn of the twentieth century. While many inventions—such as the steel plow, the horse-powered mowing machine, and even the mechanical thresher—had greatly increased farm production throughout the nineteenth century, none matched what the tractor brought to the farm. These new machines could tirelessly work more acreage than any pair of horses. The enormous tasks associated with crop work, such as plowing, planting, cutting, baling, and threshing were reduced simply to time spent on the seat of a tractor. The tractor extended the work any one person could do tenfold, bringing the promise of the Industrial Revolution to the farm.

Free stall dairy barn.

As always, new technology was brought to bear on the age-old problem of handling manure. Cattle stalls were built with trenches cast into the concrete floor behind them. Farmers shoveled manure by hand into the trenches, where manure draggers, chain-driven paddles within the trench, would drag the waste out of the barn and dump it into a waiting spreader.

Tractors hauled and spread the manure or moved it to piles or pits for storage until needed on the fields, leaving the barn a cleaner and more healthful place. As previously mentioned, about a hundred years after farmers figured out that barns were best left free of manure, new barn designs came along and put it right back under the animals producing it. Many

twenty-first-century "free stall" barns are built over shallow cellars. Cows simply walk on their own manure and push it through the grated floor of the barn into the manure pit below. From there the liquefied manure is pumped out into tanker trucks that spray it back onto the fields. The free stall barn is an open affair, curtained off only in the coldest winter months, so the fumes don't pose a problem to animal health. While Connecticut farms never reached the level of factory farming practiced in Western states, they nevertheless did mechanize, trying to keep ahead of economic pressures.

Dairy farming's increased importance in the state meant that new storage facilities needed to be built to handle the feed requirements for larger herds. On subsistence farms, if feed was not stored in the main barn, corncribs and small granary buildings had been enough to hold a year's crops. To handle the herd's needs, however, vertical silos began to dot the landscape. As improvements were made, blowing and lifting machines attached to tractors allowed farmers to fill ever taller silos, which were built of nearly every material imaginable. Wood, of course, was used for many silos,

but farmers also experimented with stone, brick, concrete, tile, and eventually steel. Chopped feed such as corn was blown into the top of the silo, where it would fall and compress under the weight above. In the absence of oxygen it would ferment without spoiling, producing silage, a prime feed for dairy and beef cattle. Vertical silos have now, for the most part, been replaced on the working dairy farms left in Connecticut. Horizontal bunkers are now the preferred way to handle feed crops. To build these bunkers, large concrete-wall sections are placed onto a concrete pad. Truckloads of chopped corn or hay are dumped into the bunker and then compressed by tractors rolling back and forth across the feed to rid it of air. These piles are then covered with plastic to make the bunker airtight and to allow the fermentation process to occur. This new "barn" would hardly be recognizable to the men who built the first English barns in Connecticut, although they might appreciate its efficiency. As with most changes on the farm, this new system allows fewer people to do more work by mechanical means. While this system has replaced silos, barns are still used to store dry grasses fed to cattle.

In the twenty-first century, barns have continued to change to accommodate new inventions and new theories of farming efficiency. As farmers move forward, they either tear down old barns to build more modern facilities, or simply add new barns to their farms while continuing to utilize the older structures for simpler tasks. It is not uncommon to see old English barns surrounded by modern structures on Connecticut farms. Barns that stood unchanged for centuries often remain viable in the world's evolving economy.

Barns Today

There are thousands of historic barns of all sizes and types in Connecticut. Where they once overlooked open farmland, they are now, more likely than not, hidden by trees or crowded into the corners of developments; homes and factories have replaced the open fields. Old barns are found in various stages of repair, from pristine to collapsing. Now long removed from our agricultural roots, we find that barns are no longer essential to our survival. While some people in the state still depend on barns for their livelihood, more often than not old barns stand vacant.

Early barns represent a time when the interdependence between humans and nature was a given. It is now possible to live almost completely shielded from the natural world, and many of us do. We live in a country in which a small percentage of the population provide food for the rest, and where many of us have little or no idea where our food comes from. It is possible to eat a meal in New England oblivious to the fact that our food has traveled the breadth of the country to reach our table. But that is beginning to change. Small farms devoted to growing food for the local population are springing into existence across the state, and with them, the need for barns in which to work and store crops. The U.S. Department of Agriculture listed 4,191 farms in operation in Connecticut in 2002. Just five years later, there were 4,916.

In addition, the state of Connecticut has been encouraging barn owners to maintain their buildings, and it awards restoration grants to significant barns in need. When time and money allow, many owners choose to help preserve their barns, and having already survived hundreds of years, these buildings often prove resilient. As the state's population looks again to local

farms to supply them with fresh produce and meats, new life will undoubtedly spring from now empty barns. There is good reason to hope that barns will remain an important feature of the state's landscape for generations to come.

The barn, perfected so early in its history, can be as useful in the twenty-first century as it was five hundred years ago, and today's builders are honing their designs with an eye to the early barns' triumphs. The open design, strength, and versatility of the barn allow for any imaginable use. Beautiful examples grace the state, and it is my hope that the images on the following pages communicate my deep appreciation for the Connecticut barn in all of its forms.

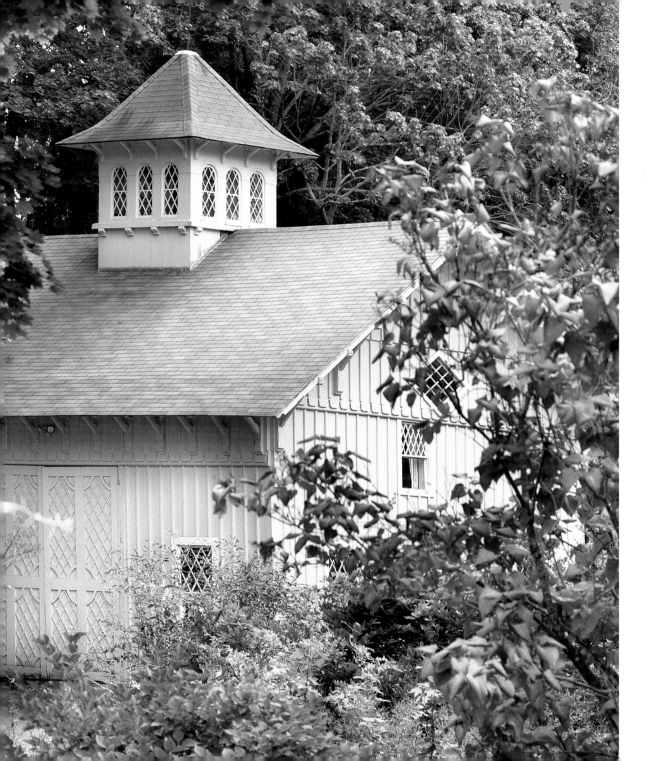

Barns of Connecticut

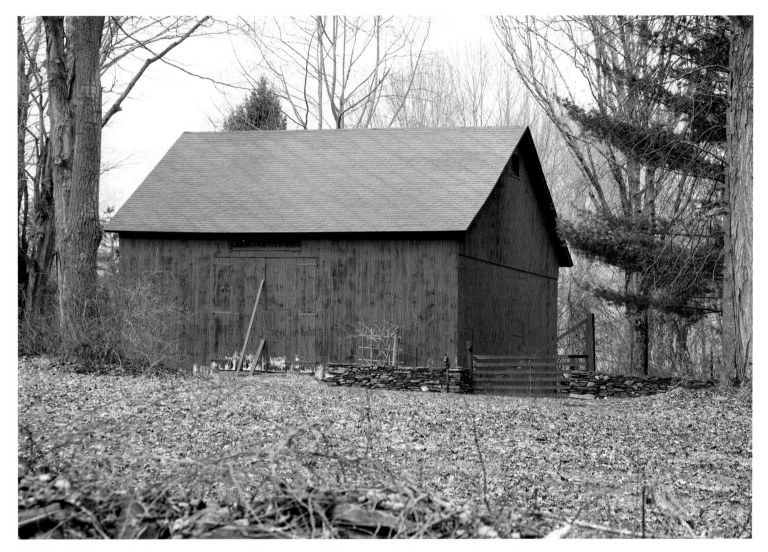

This English barn, also known as a 30x40, has transom lights over the doorway and a single window in the gable end. Barns were built in this style from the time of the first settlement into the early part of the twentieth century.

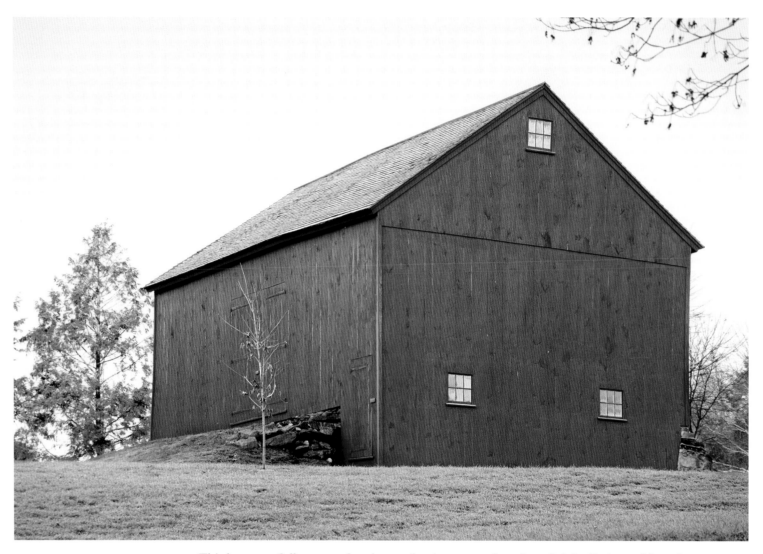

This barn was fully restored and moved to its present location. Originally, it would not have featured windows in its end wall. The stone and earthen ramp to the main doorway is typical for an English barn.

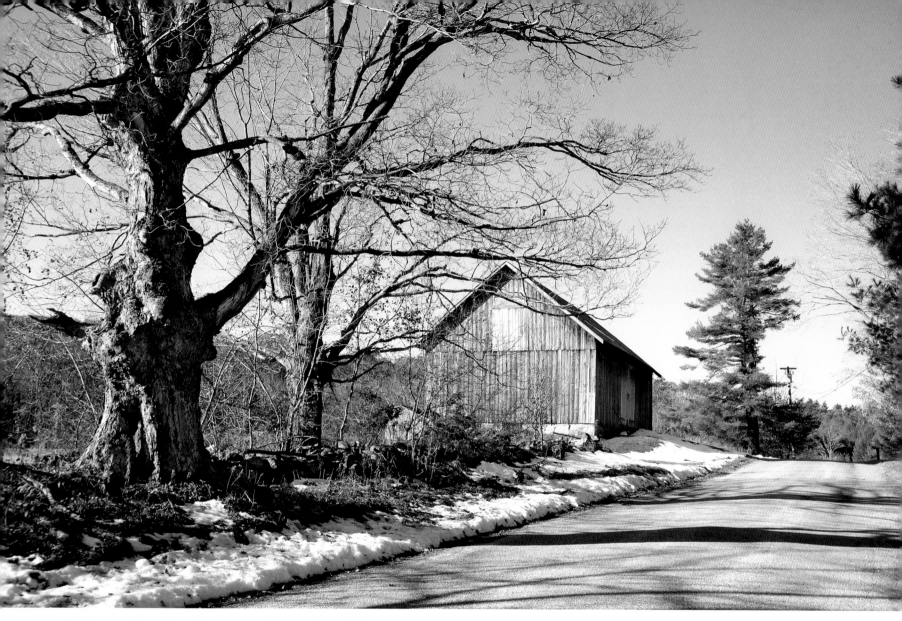

Little more than dirt trails connected farms when this barn was built.
Today, high-speed roadways often crowd early barns.

This gunstock corner post is typical of early framing techniques. Both the plate, coming from the left, and the bottom chord of the principal rafter system, coming from the right, need to land on top of the post. The post is flared to accommodate these two timbers.

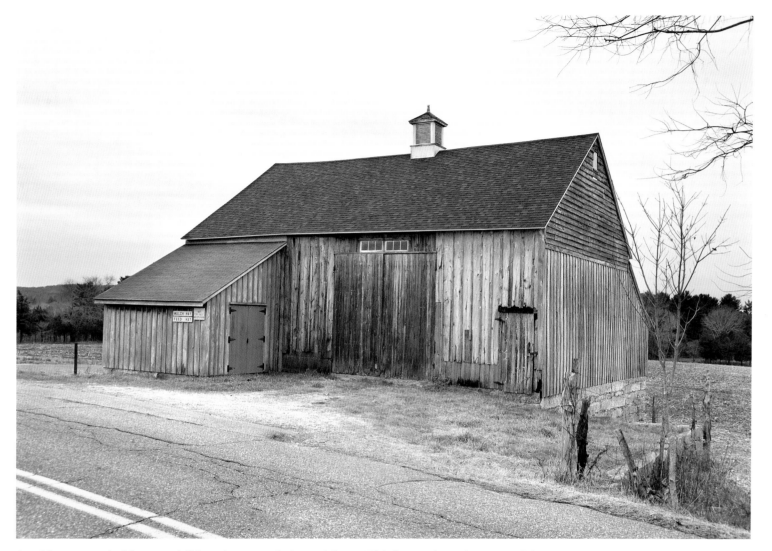

As with most period barns, additions increase their usefulness. This barn takes advantage of the hillside to create space beneath the barn for animal pens or storage. The small door on the right end of the building allows for easier access when the large doors are not required.

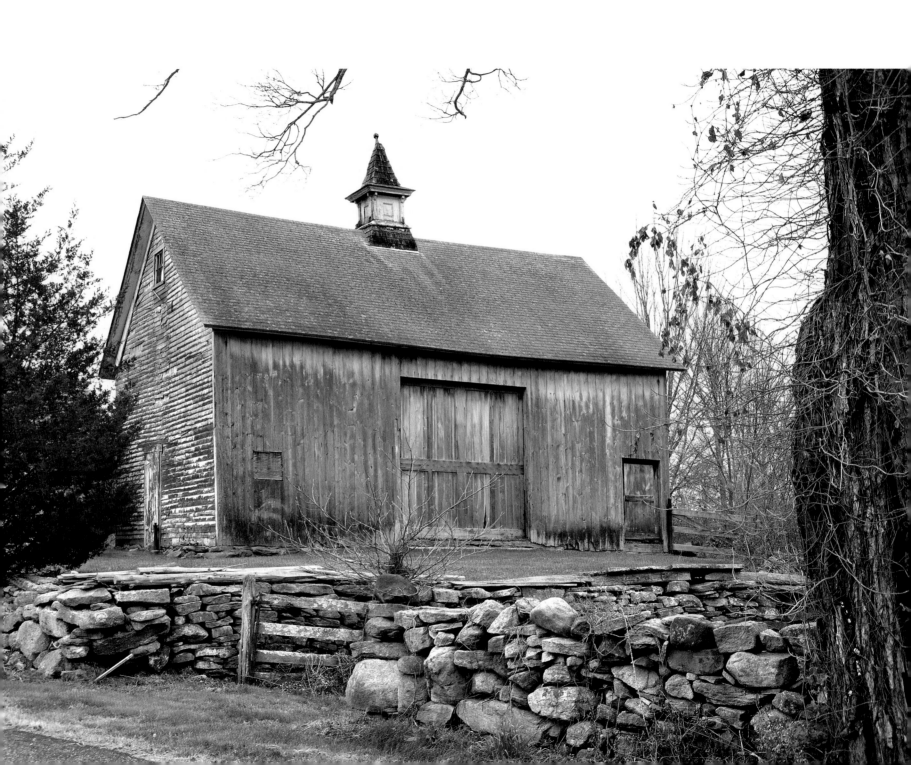

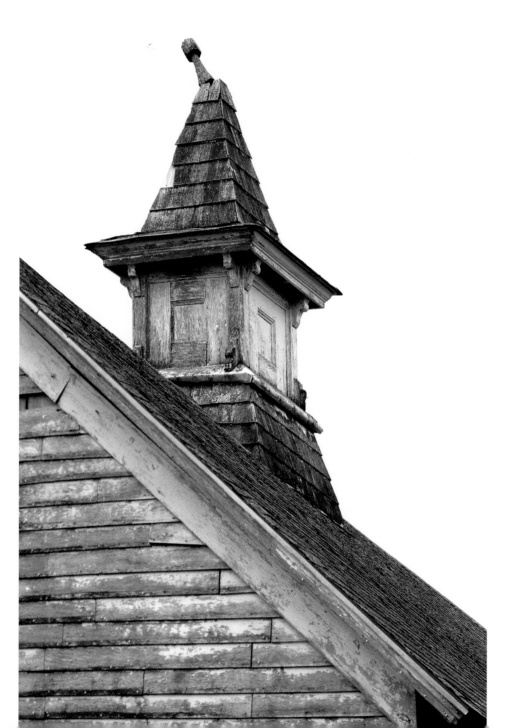

The cupola on this barn is unusual in that it is purely decorative and does not provide any ventilation.

opposite:
When possible, barn builders took advantage of terrain, such as a small hill, to keep the building well drained. This barn is also situated to benefit from sunlight.

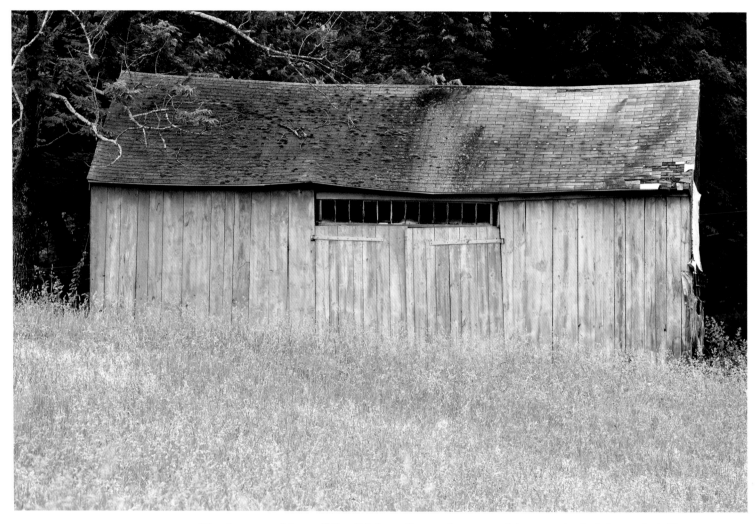

The doors on this small English barn feature long strap hinges typical of the period. Transom lights above the doorway help illuminate the interior when the main doors are closed.

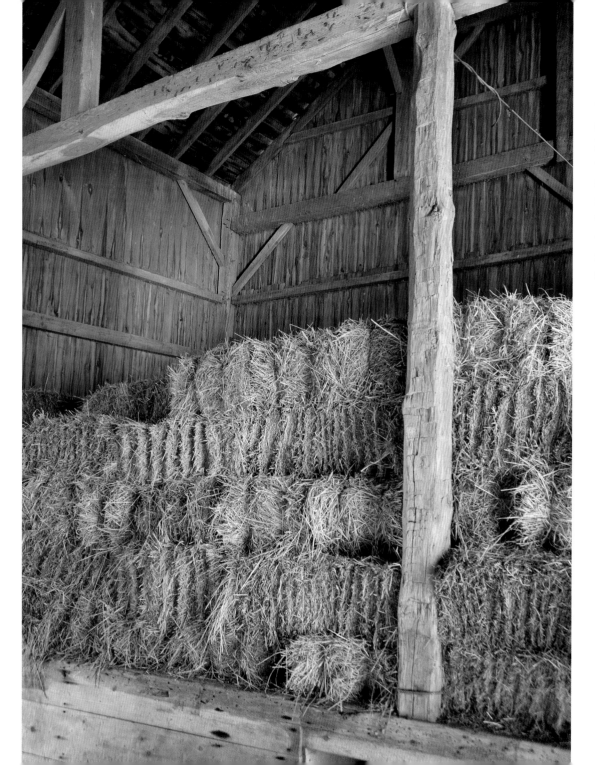

This barn is still used to store hay for dairy cattle. Note the hewn timbers and the corner post in the rear of the building. Rather than flaring the posts at the top to receive the plate and the girt, the girt is simply mortised into the post a foot or so below.

The right bay of this barn was probably a later addition, as was the sheet iron roof. Farmers usually extended the lives of early barns as best they could rather than build new.

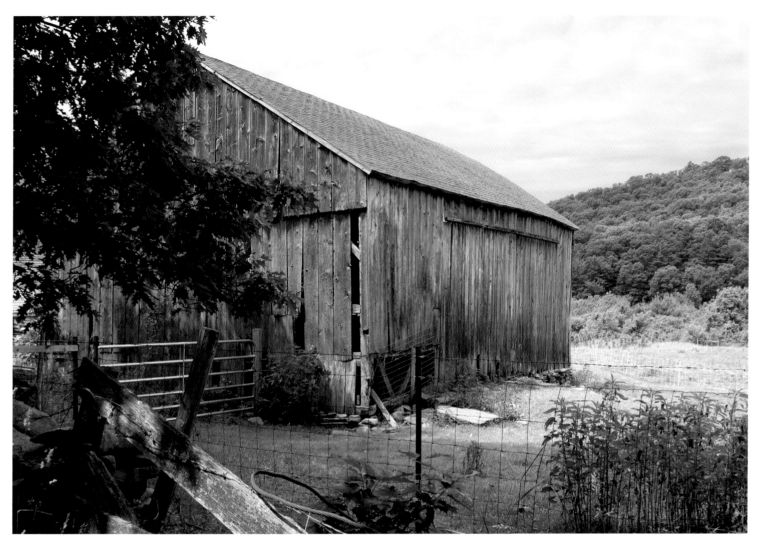

Roofs did not overhang sidewalls by more than a few inches in early barn construction.
As no gutters were used, rainwater dripping from eaves often rotted sills and the lower
ends of siding materials.

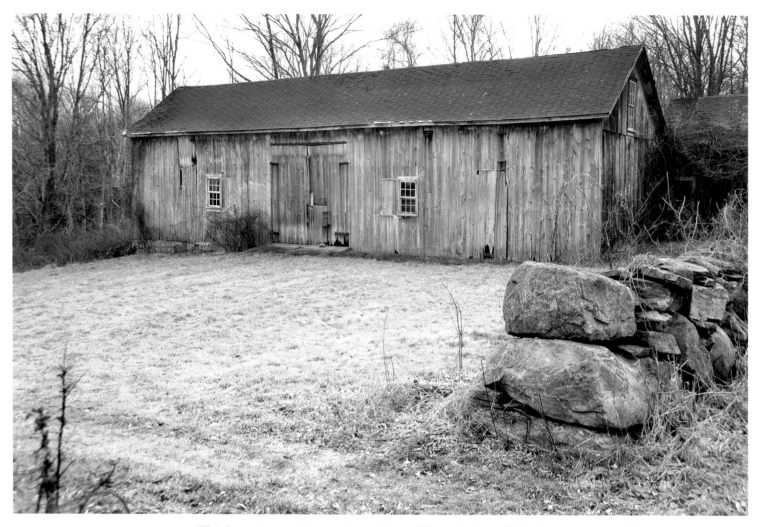

This barn is part of a complex of barns. The right bay of this barn was extended at some point in its history. Note the small doorway built into the main door.

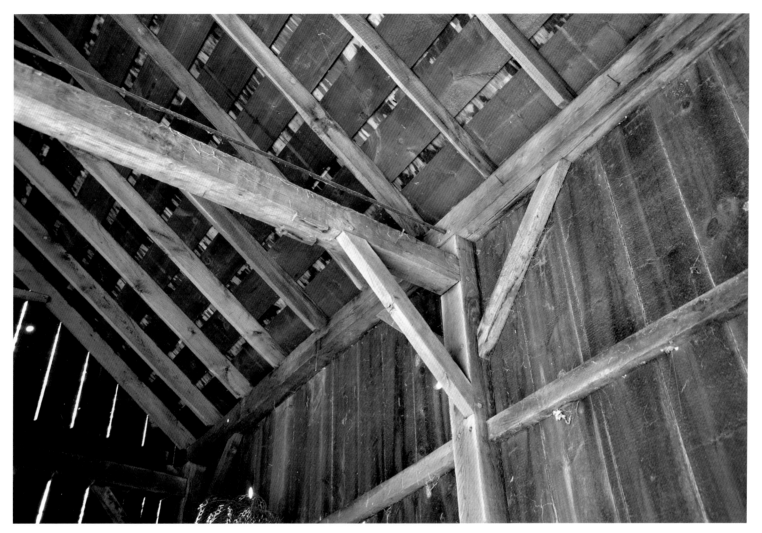

Wind braces, short struts that join framing members at 45-degree angles, add rigidity to frames.
This barn uses a common rafter system and vertical plank siding. From the inside of early barns it
is easy to see from where the ventilation comes.

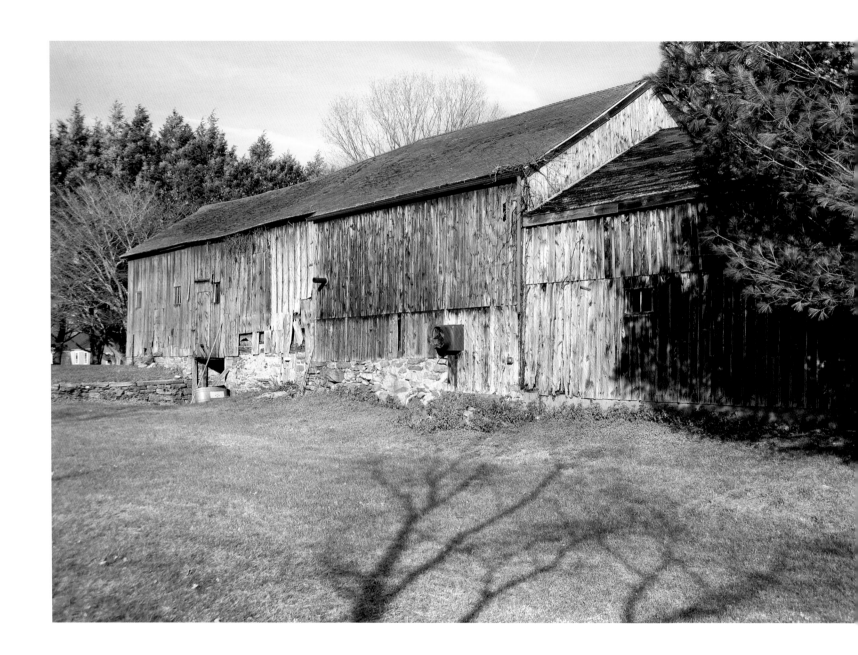

Except for the sliding main doorway and the overhanging roof, this barn is nearly indistinguishable from barns built any time during Connecticut's history.

opposite:
This barn was created from four individual barns joined together, a common practice given the time and materials needed to build them.

This eave-entry barn has been resided with novelty siding on the front and clapboards on the gable end. To fulfill new needs, another barn, whose gable peak can be seen along the ridgeline, was added to the original structure.

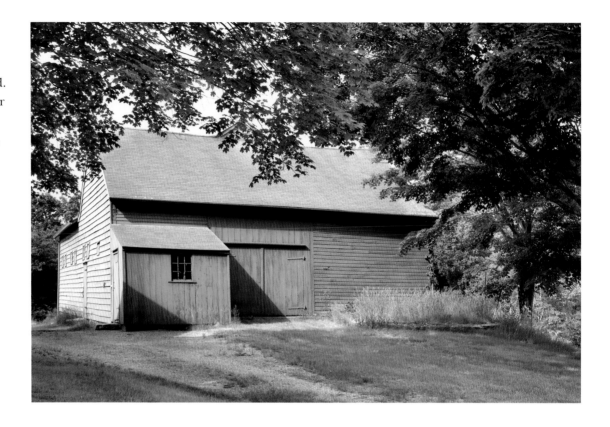

opposite:
This barn forms an ell with the barn above. The cellar under this section may have provided a place to store manure through winter months or to house animals and equipment year round.

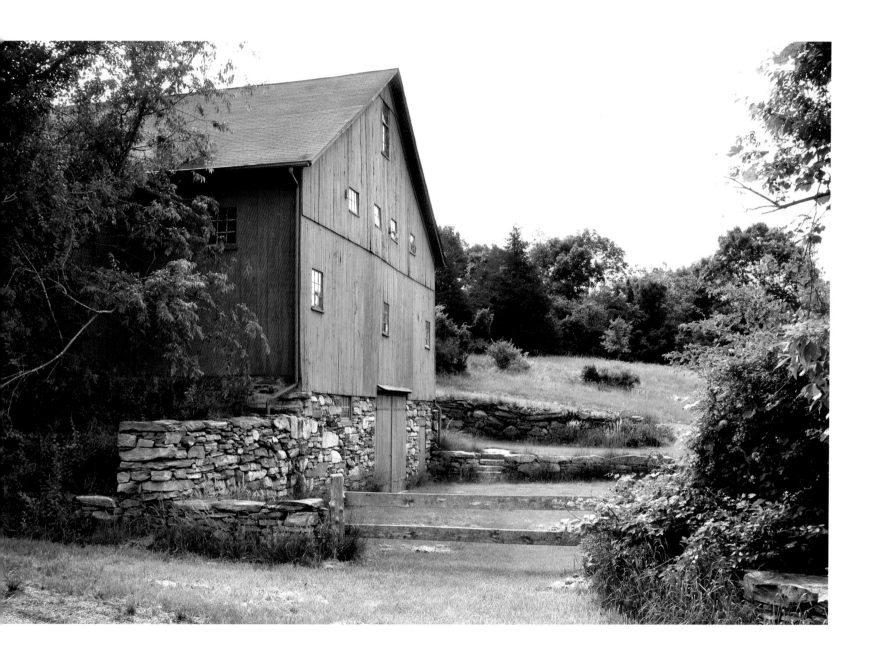

All that remains of this bank barn are the cut stone foundation and iron axels from a wagon. This farmer took advantage of the stone outcrop at the back end of the foundation.

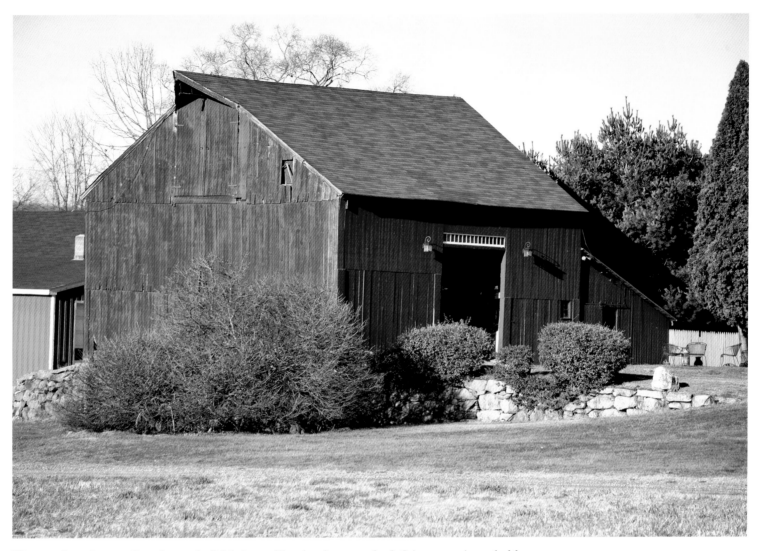

The overhanging roof on the end of this barn, like the doors to the loft it covers, is probably a late addition. Wagon loads of hay could be lifted by horse forks up to the loft doors, greatly reducing labor.

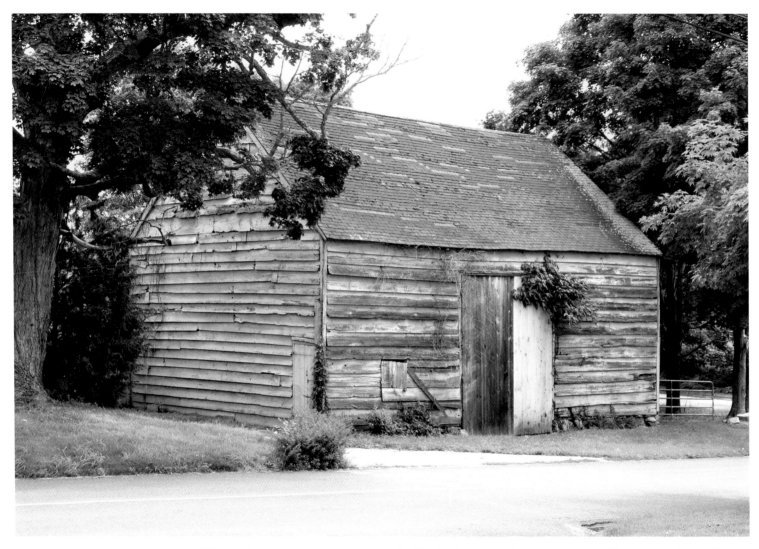

This ancient looking barn is covered with clapboards only; there are no siding boards beneath them. The little square doorway to the left of the two main doors probably functioned as a window to a small animal's stall.

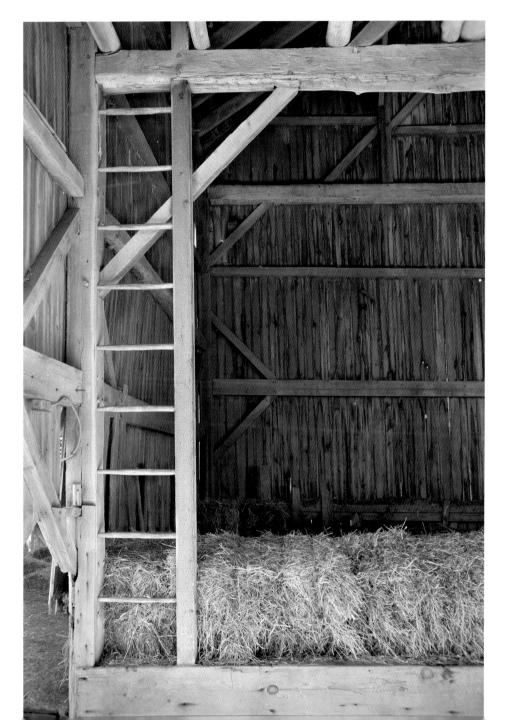

Access ladders to lofts or mows were usually built right into frames, as in this image. Note also that the floor joists at the top of the image are not mortised into the girt; they simply rest on top.

Exterior-mounted rolling doorways like this often replaced traditional swinging doors in an effort to minimize snow removal. These doors are also easier to handle in the wind.

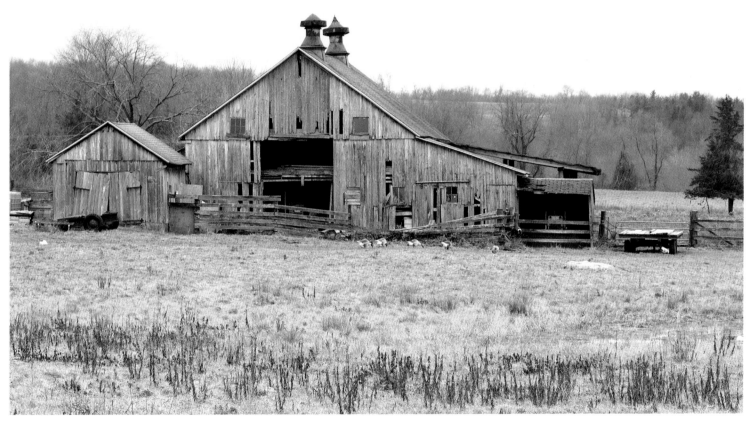

While this may look like a gable-entry building, the opening in this end was created simply by removing the siding to allow new access to an old barn.

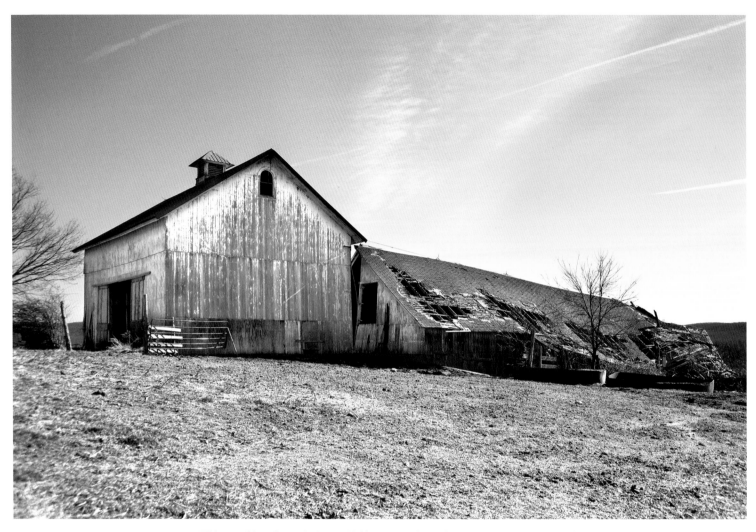

This working barn is beautifully situated on the top of a hill overlooking hundreds of acres used to raise hay and corn. The newer structure, now collapsed, was used to store hay once the taller barn ran out of space. This well illustrates the difference between timber framing and modern stick framing.

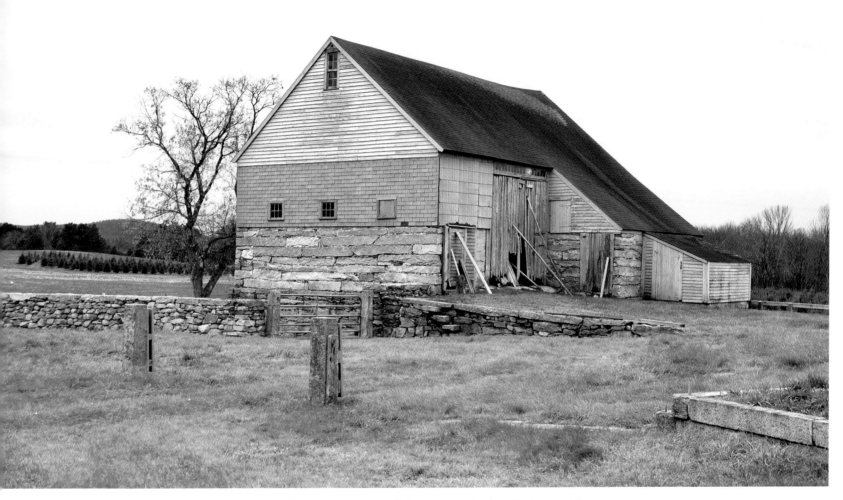

This barn is noted not only for the quality of the stonework that forms the foundation and first floor but also for the quality of the stone walls surrounding the fields. Because of its expense, cut stone was rarely used. A nearby quarry provided the stonework for this barn and another one just down the road—the barn on page 57.

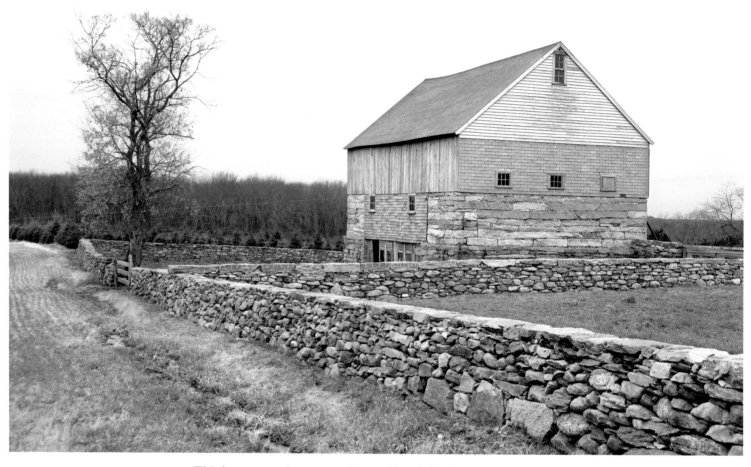

This barn recently supported a working dairy farm. Note the variety of siding materials now covering the structure.

Note the beautiful forged hinges on this doorway. The left end of the hinge was flared to allow for extra fastenings.

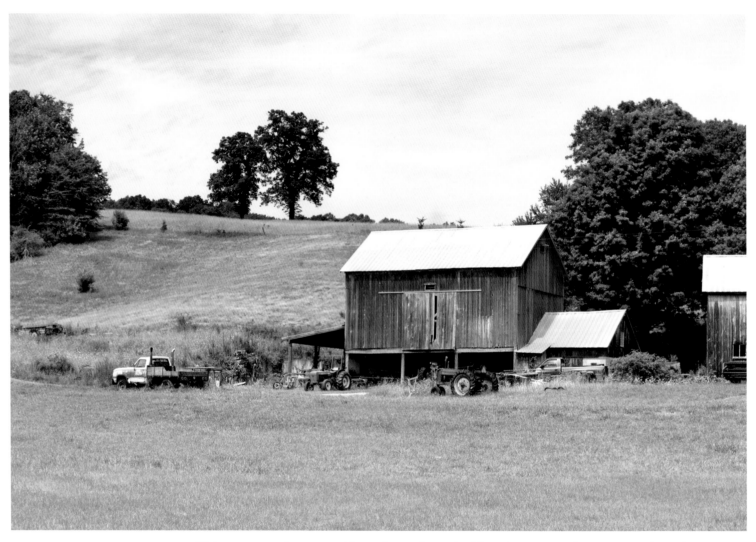

This eave-entry barn was either relocated or raised into its new position atop wooden pilings to allow for storage underneath. The rolling doors are still used to ventilate and light the interior and to accommodate a conveyor.

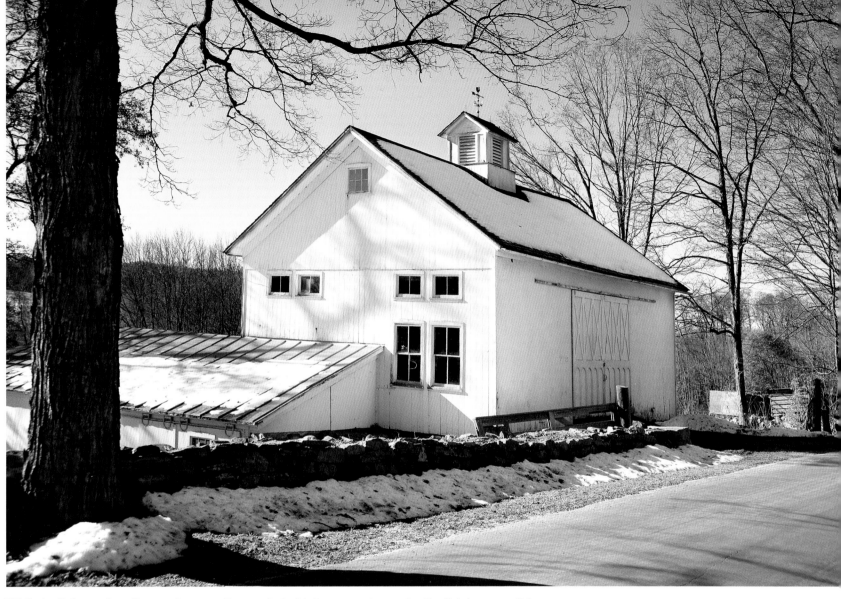

While built long after Connecticut was first settled, this barn continues the English barn tradition.
Cupolas began to appear on barns in the early to mid-1800s.

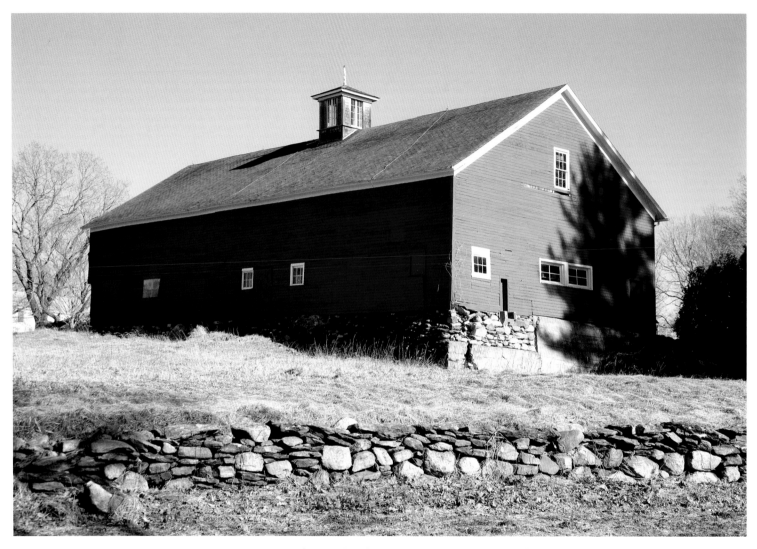

Farmers may once have gained access to cellar space from the gable end. Later stone and concrete work filled the end wall of its foundation. The skinny doorway on the left once drained waste liquids from the barn.

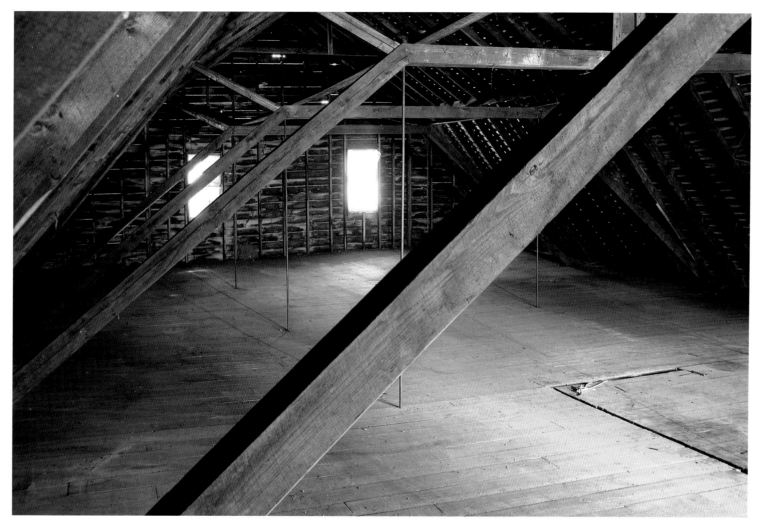

This late-nineteenth-century communal barn took advantage of a gambrel roof design *and* truss construction in the loft. Stories say that, in addition to storing hay, the loft was once used to hold the final remains of those who died in the winter and could not be buried until the ground thawed.

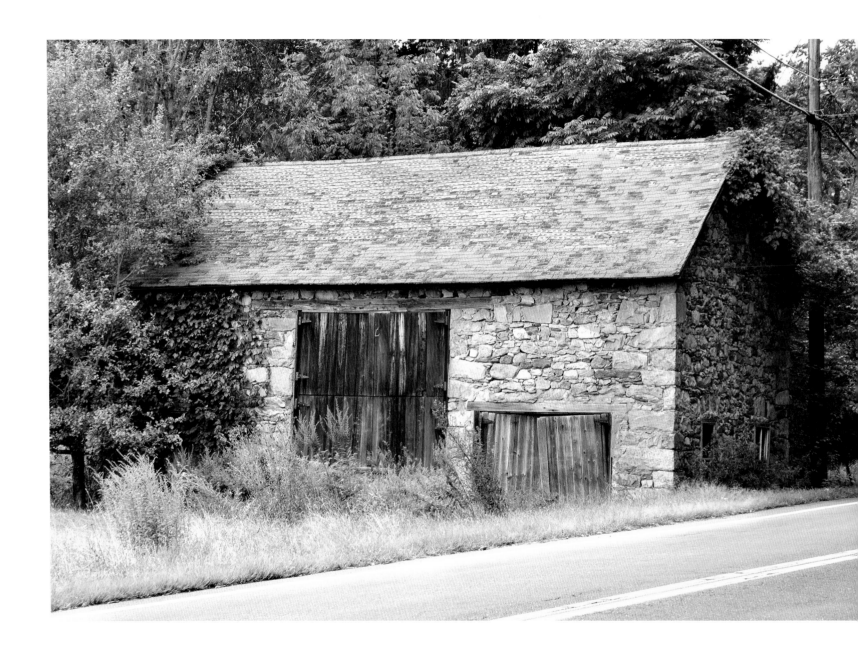

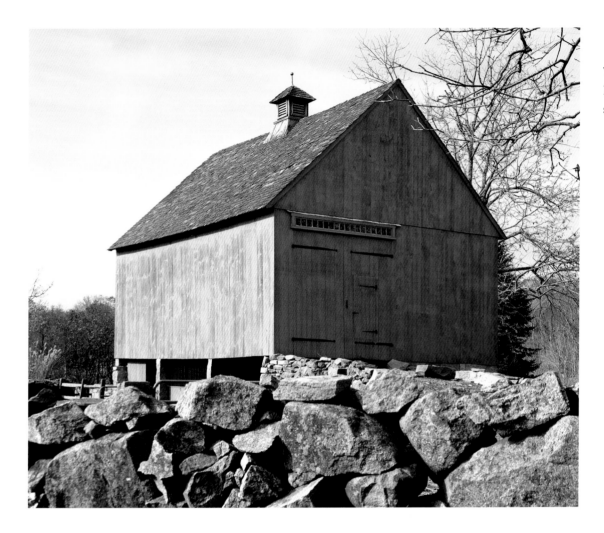

This gable-entry bank barn has beautiful stone pillars supporting it.

opposite:
Stone barns were occasionally built in Connecticut. Showing the staying power of tradition, this English style barn was built in the early twentieth century, a hundred years after having gone out of style.

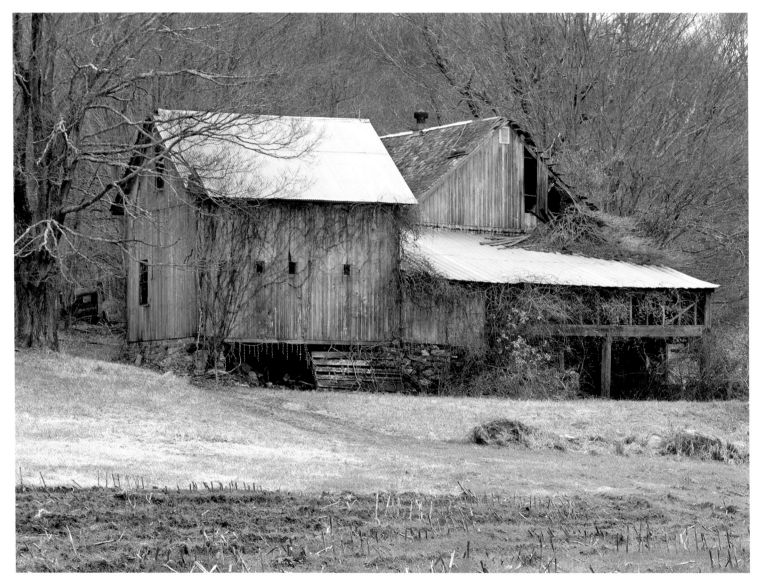

Even in decay, weathered barns have a natural beauty that seems to fit the landscape.

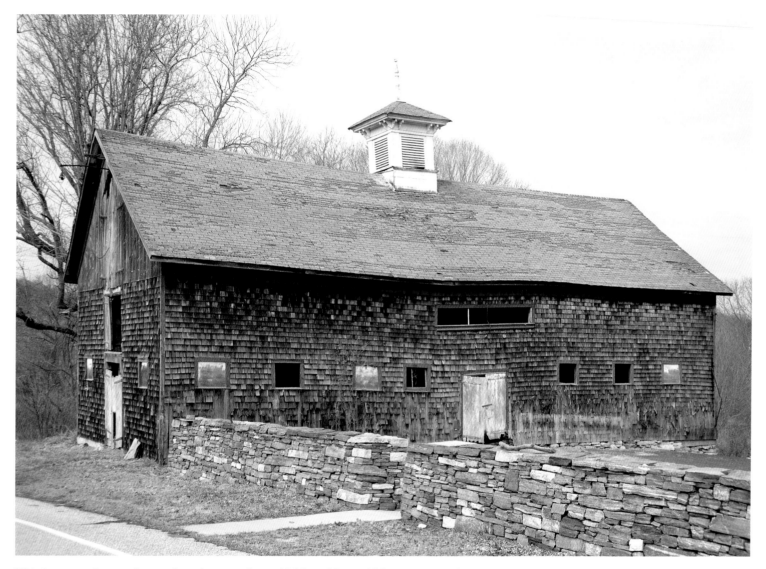

This barn, no longer in use, has the most beautiful hand-forged hinges supporting its sagging doors.

The hinges on doors
throughout this barn
all match, which is
very unusual.

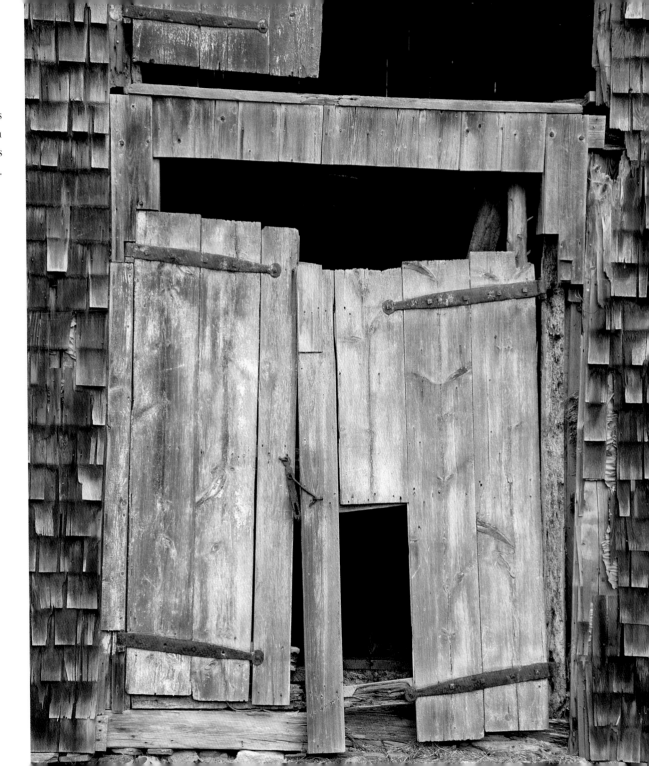

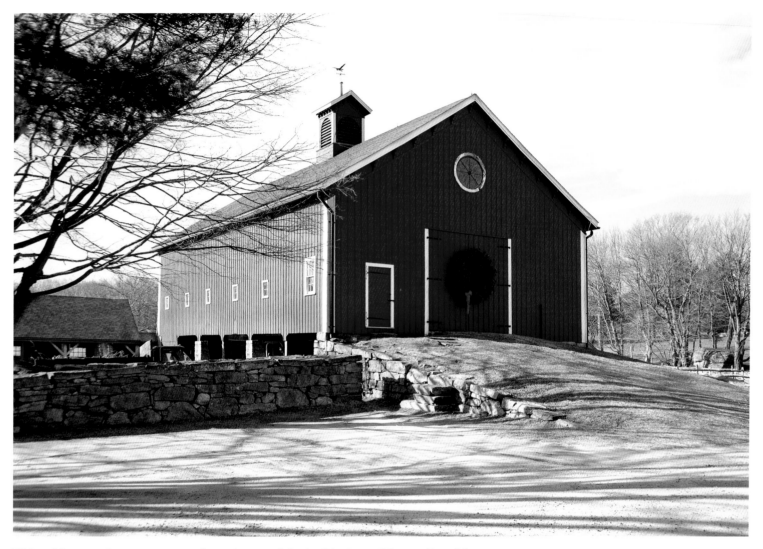

This gable-entry barn represents the epitome of the builder's art. The quality of the workmanship from the stone foundation to the cupola is first rate. Board and batten siding is used to keep out drafts.

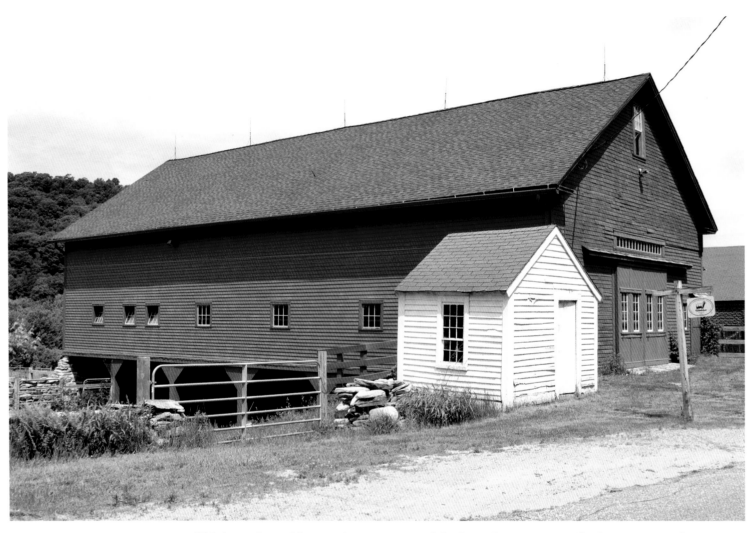

This imposing gable-entry barn augmented the barn shown on page 63. Storage space for modern farm equipment was made available under the main floor by building on a hillside. The little white building was the farm's milk house.

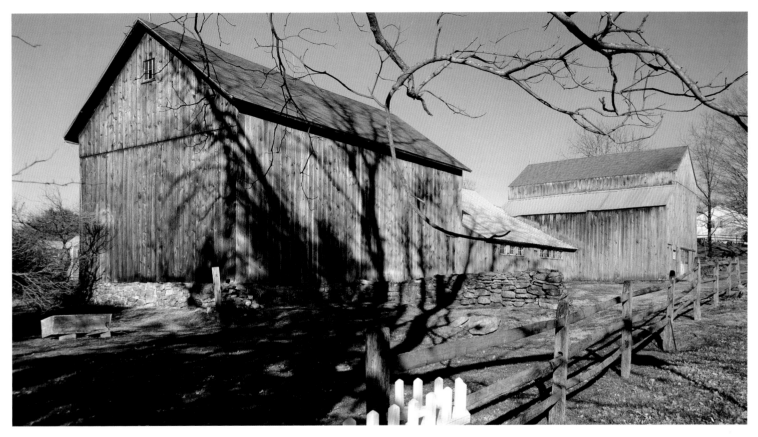

This wonderful barn complex, once set in the middle of rolling hills, is now surrounded by congested urban life. The barns are nonetheless well maintained by their owners.

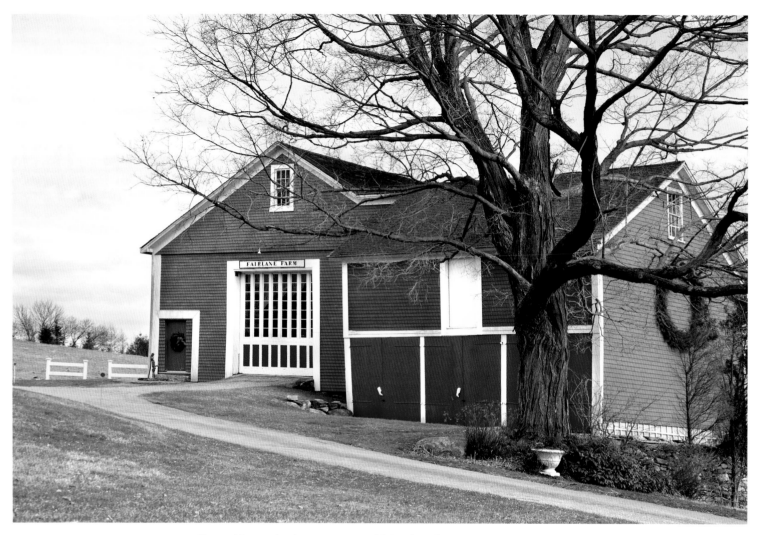

Several barns in the area around Woodstock, Connecticut, feature the heavy use of glass in the gable doorways. The barn to the right of the main barn has three bays for carriages, plus hayloft space above.

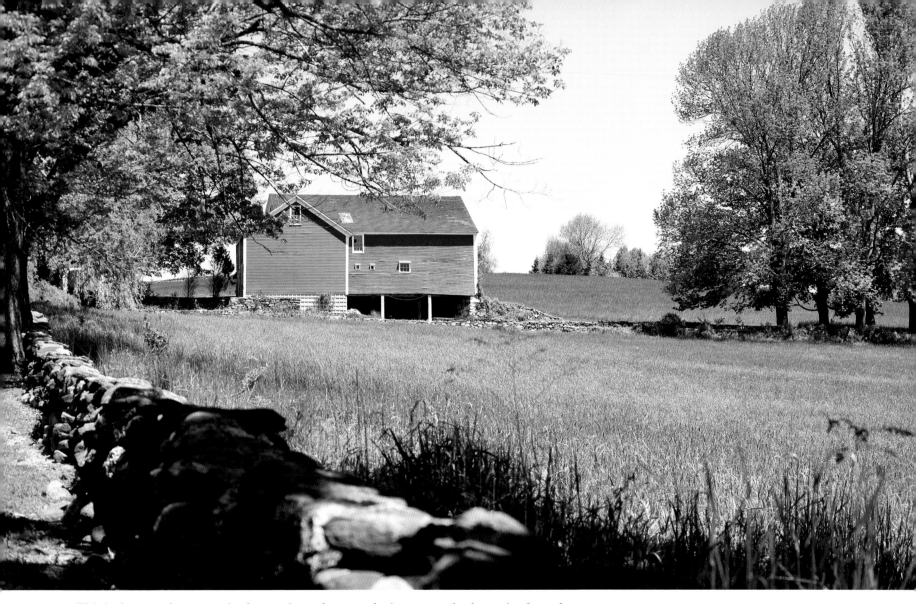

This is the same barn seen in the previous photograph. As was standard practice from the early 1800s forward, the farmer took advantage of the hillside to produce an open cellar for equipment storage.

This magnificent barn in Connecticut's northwest corner is really more of a carriage shed. Because it was built in the center of town, hay for the horses had to be brought in from surrounding farms.

Moisture steams the windows
inside this cupola of the barn
previous pictured. These windows
open to ventilate the building.

To dress up this carriage barn, its owners decided on a relatively simple window trim. Fret-sawn brackets hold a flat board over each window, adding immeasurably to the charm of the building.

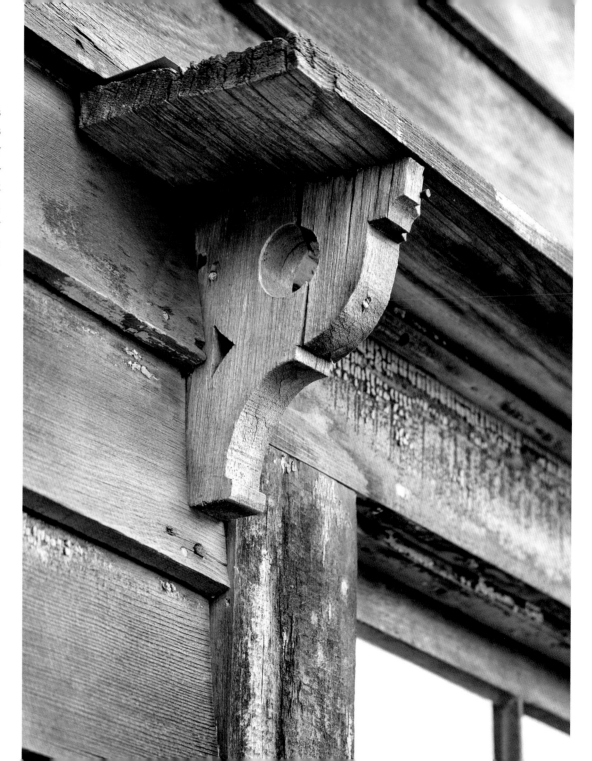

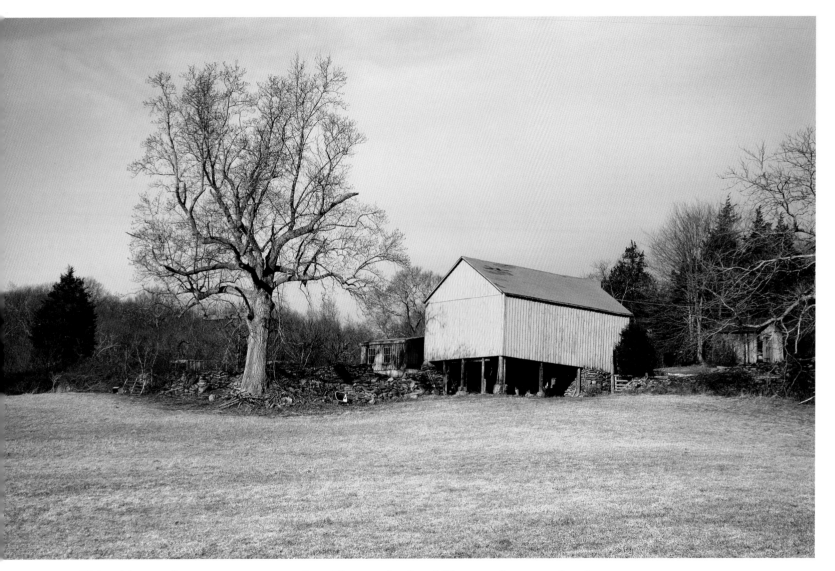

This gable-entry barn now rests on wooden pilings on the downhill corner. It appears that the original stonework was replaced with pilings to allow greater access beneath the building.

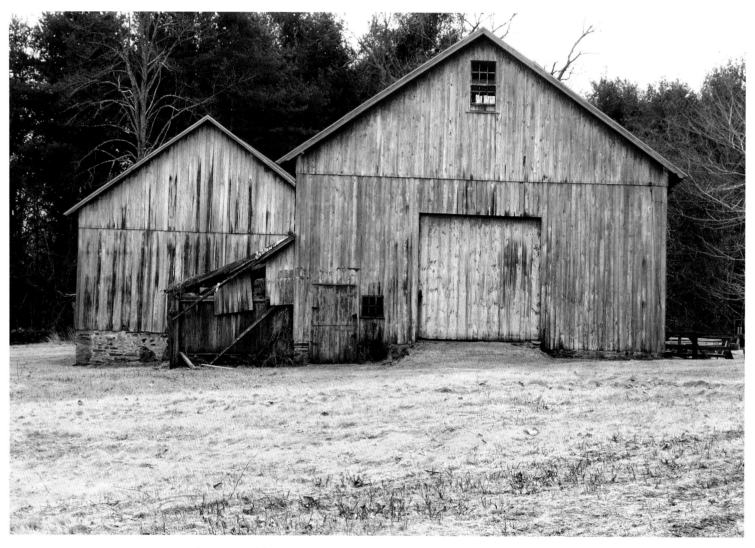

A newer gable-entry barn rests in front of the original English style barn to the left. The older barn once sat on stone piers. The openings between piers were eventually walled in with stone, perhaps as a means of keeping the building warmer in winter.

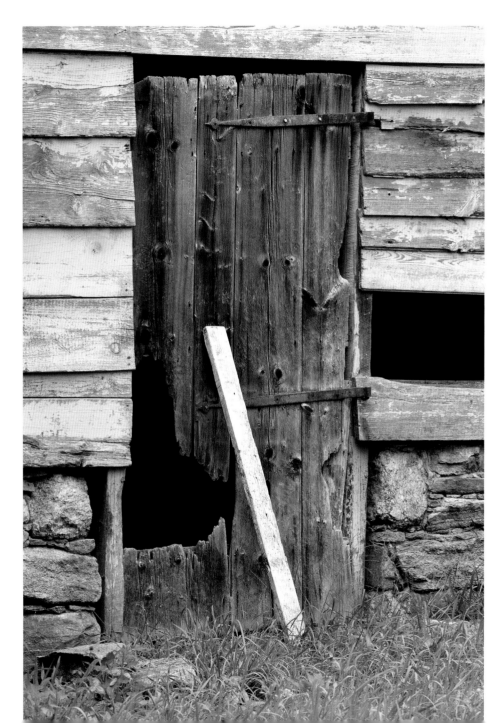

Doorways on early barns were as simple as could be made; vertical planks nailed to cross timbers on the inside of the doorway. The real work was in the hinges. These forged hinges are still beautiful, although the door itself could use some work.

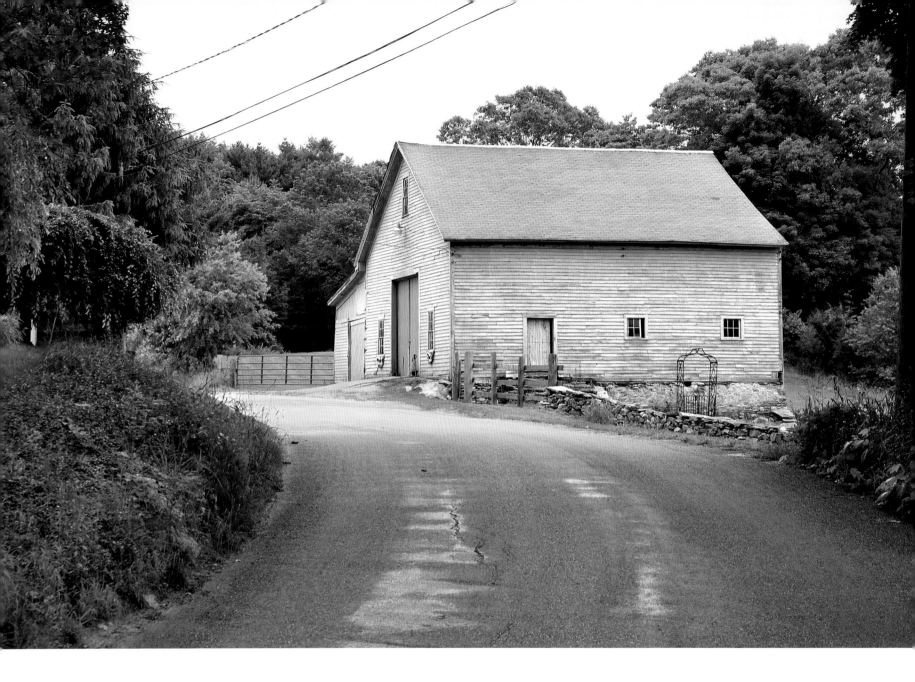

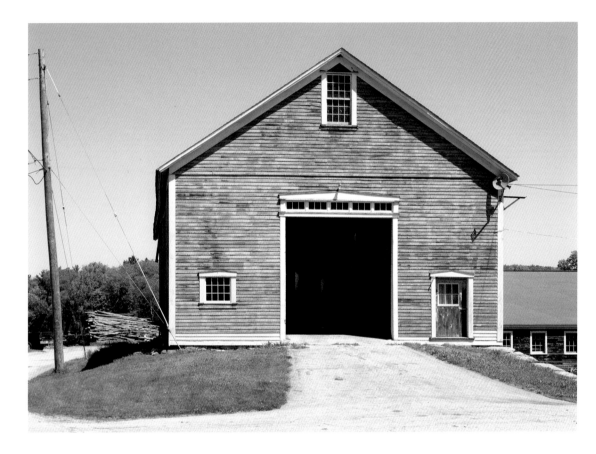

This barn seems to have lost its doors entirely. Note the Greek Revival trim around the doors and windows. Many barns began to lose their austere look in the later 1800s as new fashions in architecture were spread by farming journals.

opposite:
This barn is picturesquely situated at the top of a rise on a sweeping corner of the road. The gable-entry doors are recessed to the interior of the building, lessening the need to remove snow before opening the doors in winter.

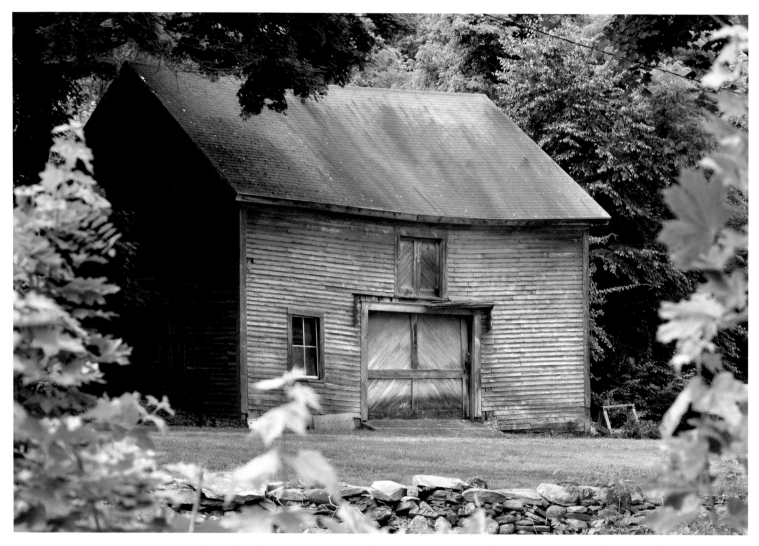

In modernizing this eave-entry barn, carpenters may have gone too far. After installing windows and an interior-rolling door they cut a new hayloft door. Unfortunately, they removed timber that supported the plate above, causing the roof to sag in the center.

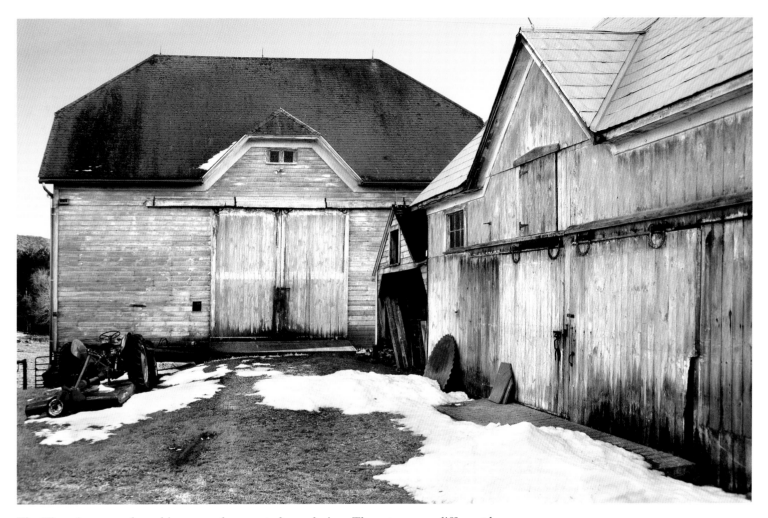

The Victorian era ushered in many changes to barn design. These two very different barns from the same period were built side by side. The complexity of the gable additions added little functionality to the structures but increased their visual appeal—and their cost.

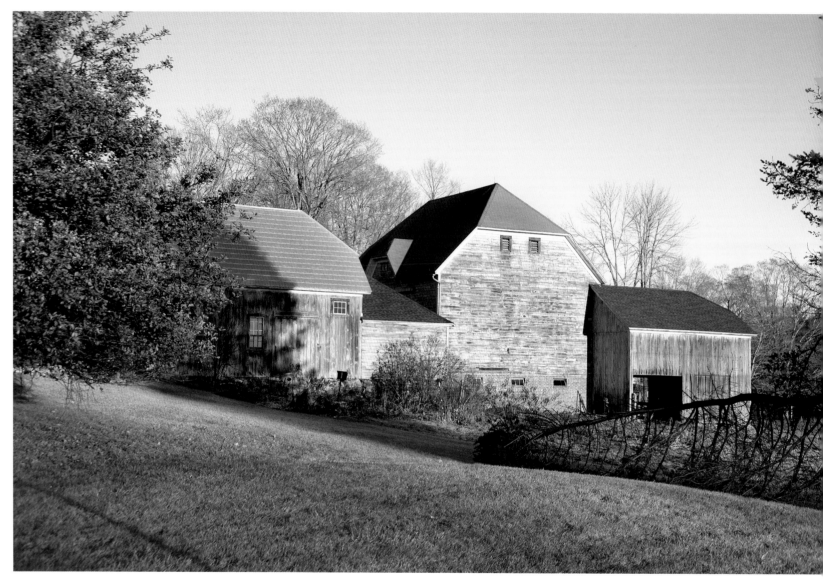

Belted Galway cows are now raised on this rural farm.

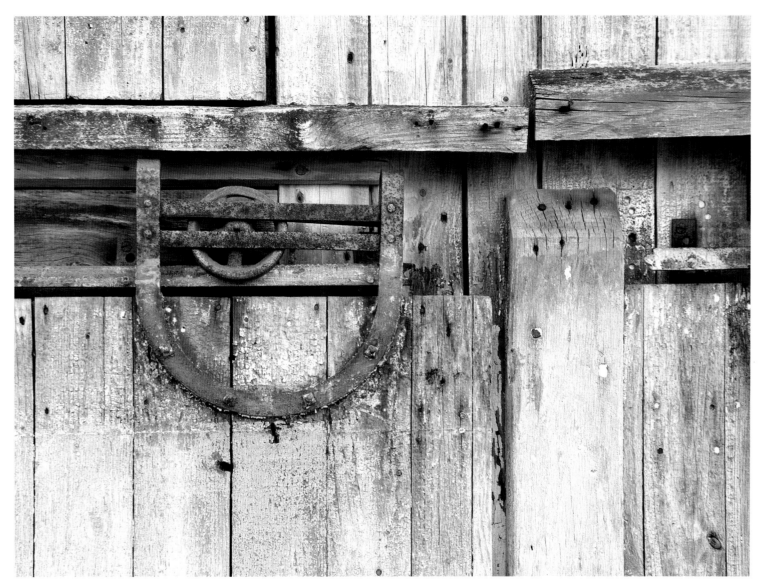

The use of rolling door hardware spread quickly, given the benefits it brought to the farm.

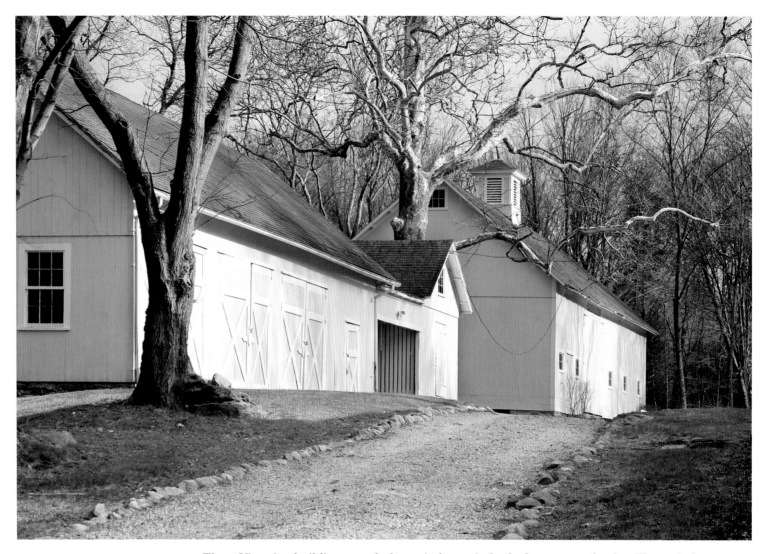

These Victorian buildings match the main house in both character and color. The main barn on the far end once provided stalls for the owner's horses and other animals. A storage loft covered the feed, and the closer shed provided shelter for carriages.

This pristine Victorian barn has a loft door on its gable end. A rolling track and tackle system lifted hay and rolled it down the length of the barn for storage. While not a barn for the working farm, it allowed gentlemen farmers enough room to house a few animals and store their feed.

As barn siding was made more airtight in an attempt to keep animals warmer in winter, new problems arose. Cupolas were added to address ventilation problems sometime in the mid-1800s They also helped to cool the barn in summer months.

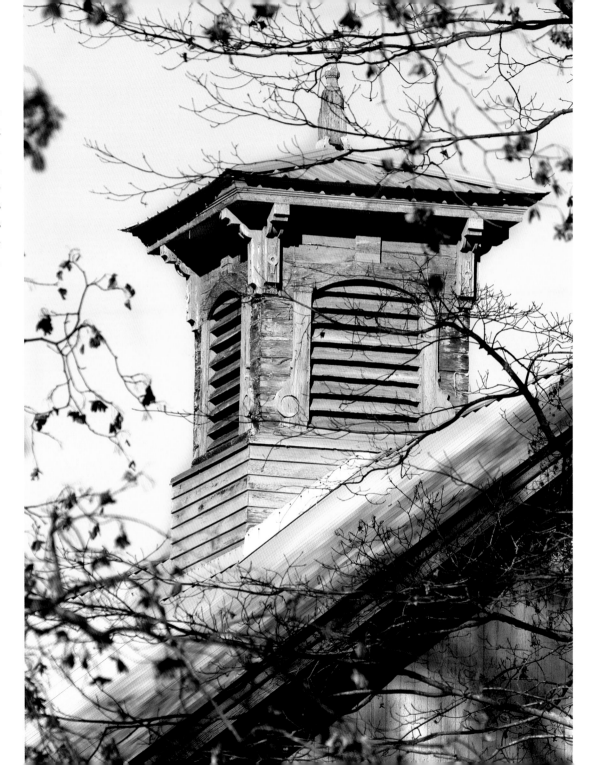

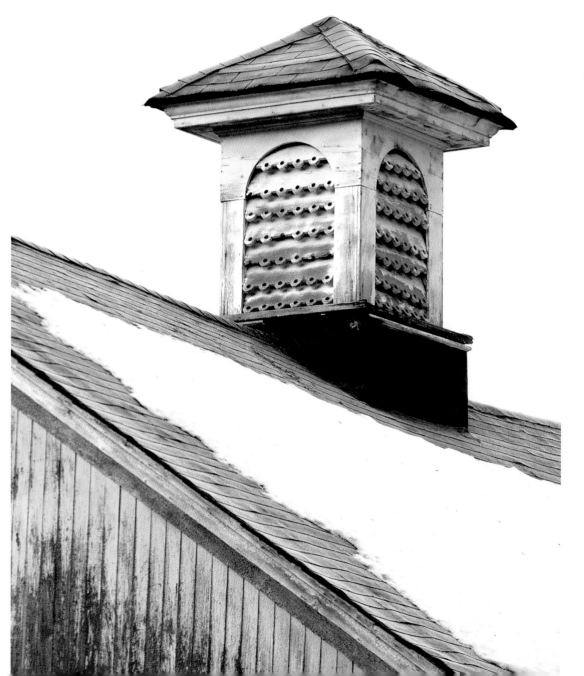

Wooden cupolas gave carpenters a chance to show off their skills and sense of design.

Once used simply to provide fresh air for this gentleman farmer's horse barn, this cupola now does double duty, bringing in television signals.

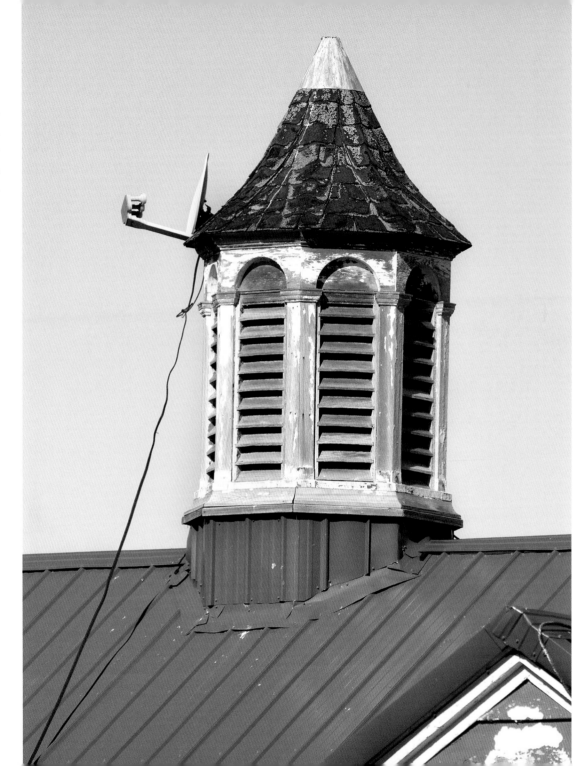

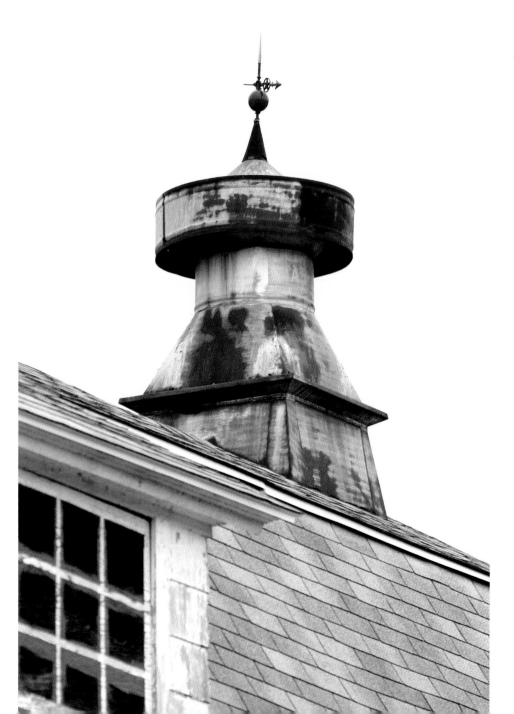

Ventilation became a serious problem as herd sizes increased on dairy farms. To help clear the air, more advanced tin ventilators were added to rooftops. In many cases these newer vents had built-in fans.

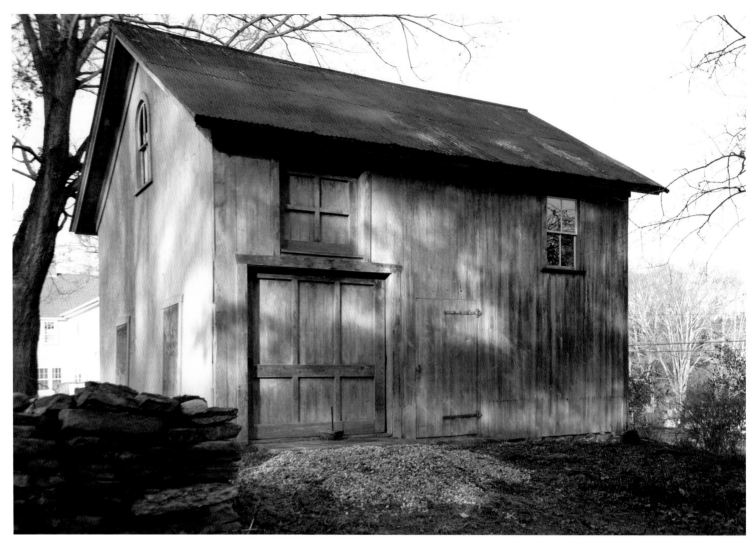

Compact barns like this were built for city dwellers—the garages of the day. This barn has a separate door for the loft and a corrugated metal roof.

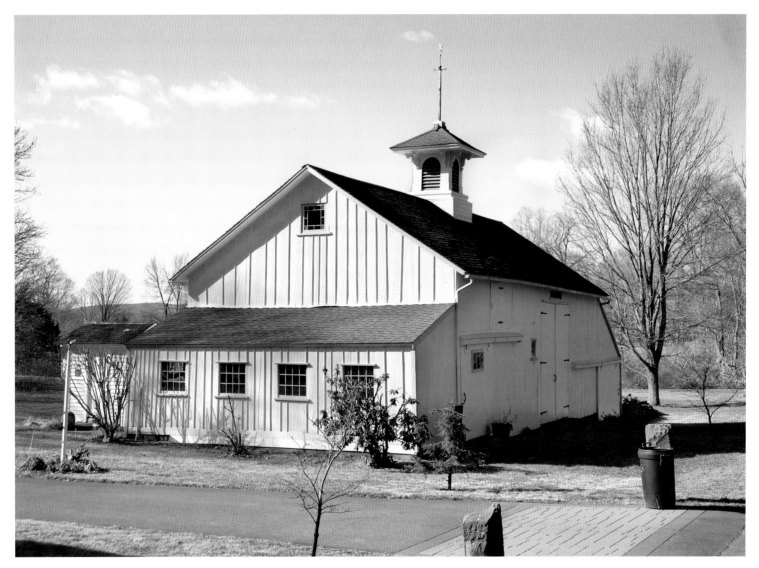

This barn, also located in the middle of a village, was used primarily as a carriage house. One can enter through no fewer than four doorways on this one side.

As if reflecting the cramped nature of the city in which they were built, these two barns rise higher than their country counterparts would have. The larger barn held stalls and hay for animals, while the smaller barn acted as a carriage shed.

opposite:
Connecticut's earliest settlers would have been shocked by the extent of the decoration on this elegant carriage house. While it functioned primarily as its namesake, its secondary role was to impress the neighbors.

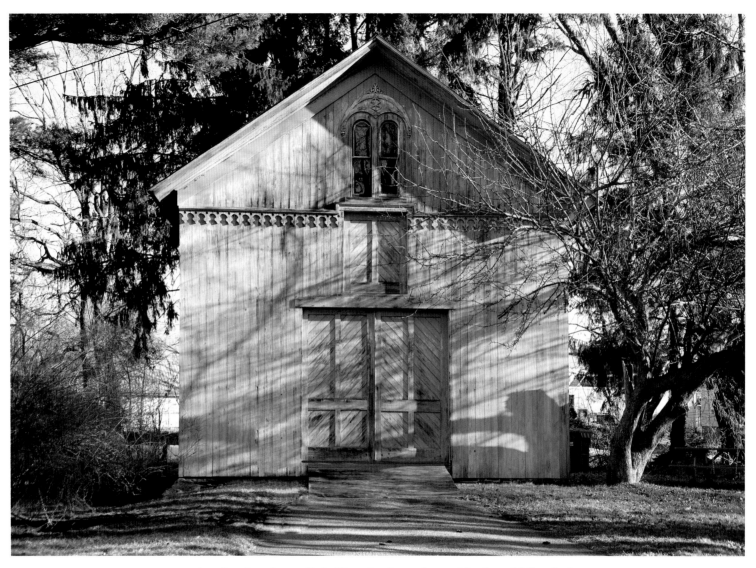

Another handsome little Victorian barn, located in the middle of a busy town, now functions as a charming garage.

Most trim on Victorian barns and homes was created in high-production woodworking factories.

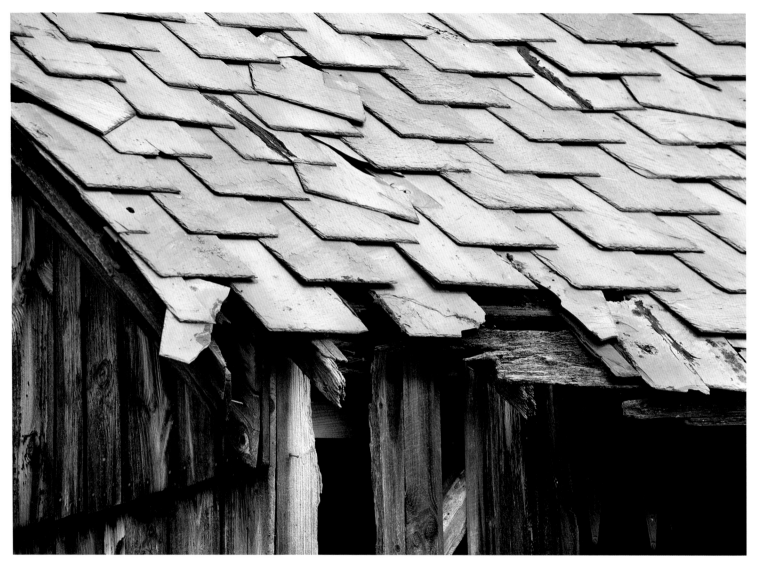

Slate was used to cover barn roofs around the state but far less often than wood, because of its cost and scarcity. This old barn is shedding its slate shingles, which does not bode well for its future.

Experimentation was the operative word in the late nineteenth century, and shingles were no exception. These interlocking metal shingles never became all that popular, probably because of the extra work needed to apply them, in comparison to sheet metal roofing. In roofing, simpler is better.

Sheet metal roofing, both flat and corrugated, as in this roof, became a popular material for working buildings because it is light in weight, low in maintenance, and easy to install. Sheet metal and the asphalt shingle of the twentieth century all but replaced the wooden roofs of the previous 250 years.

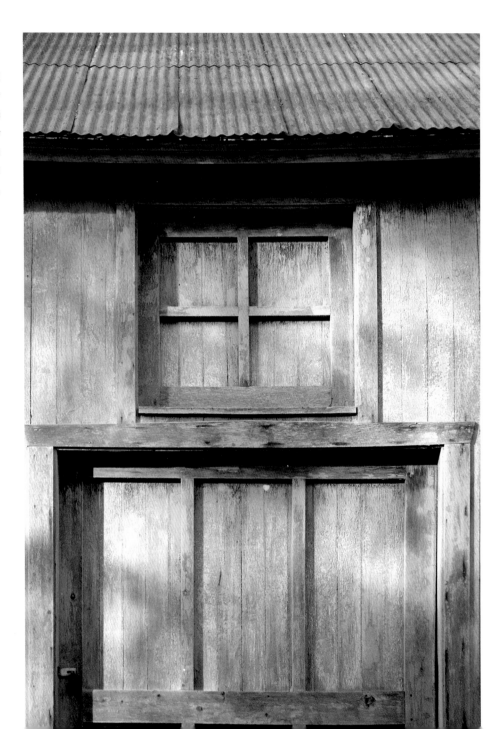

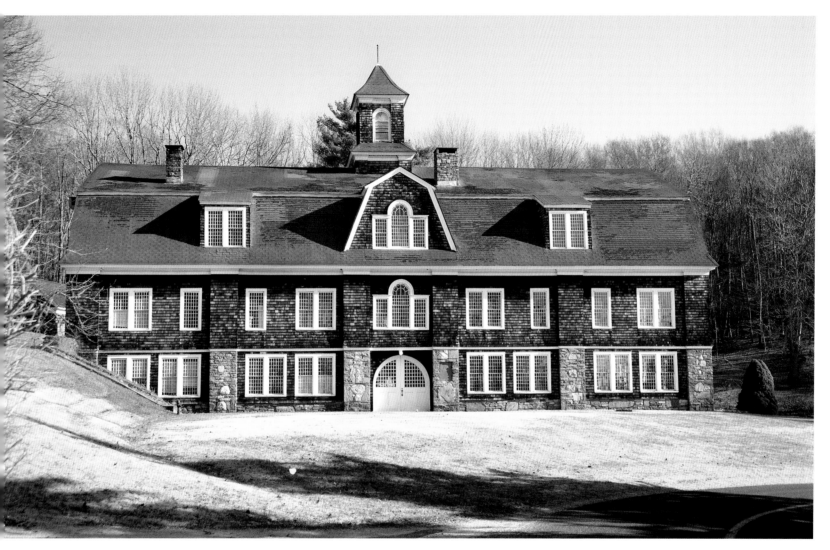

This barn represents the ultimate in gentleman farming, and probably one of the few in the state designed by an architect for an individual client. The original owner raised purebred cattle on this farm. This barn, once used to hold stock, has now been converted into a home.

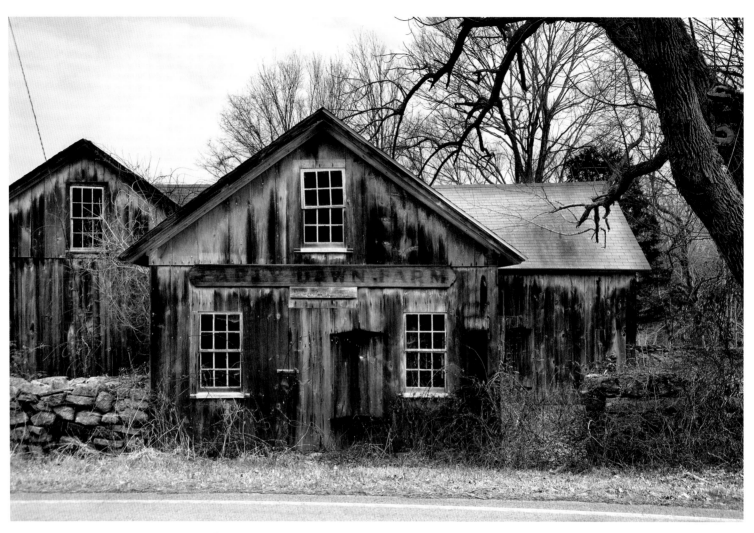

Walker Evans made these barns famous when he photographed them in 1955
and again in the 1970s.

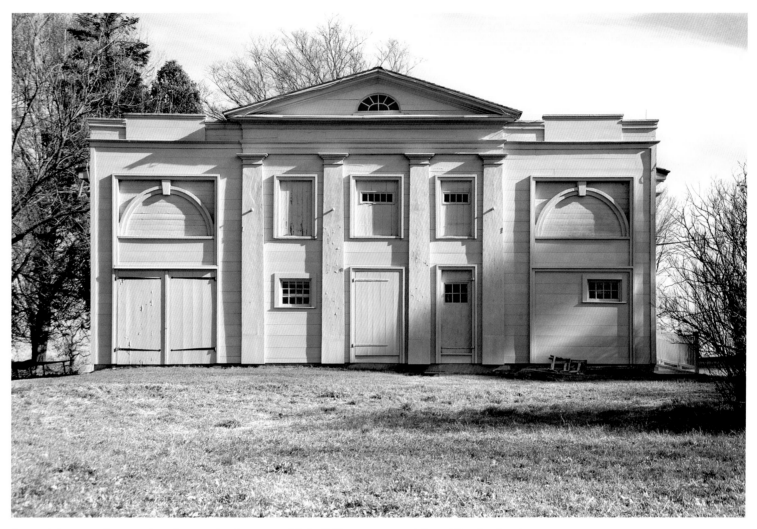

One of the grandest carriage houses in the state, this building was moved from Hartford to its present location in Lebanon. It was once owned by Jeremiah Wadsworth, who hosted a meeting between George Washington and Jean-Baptiste Donatien de Vimeur, le Comte de Rochambeau. George Washington's horses slept here.

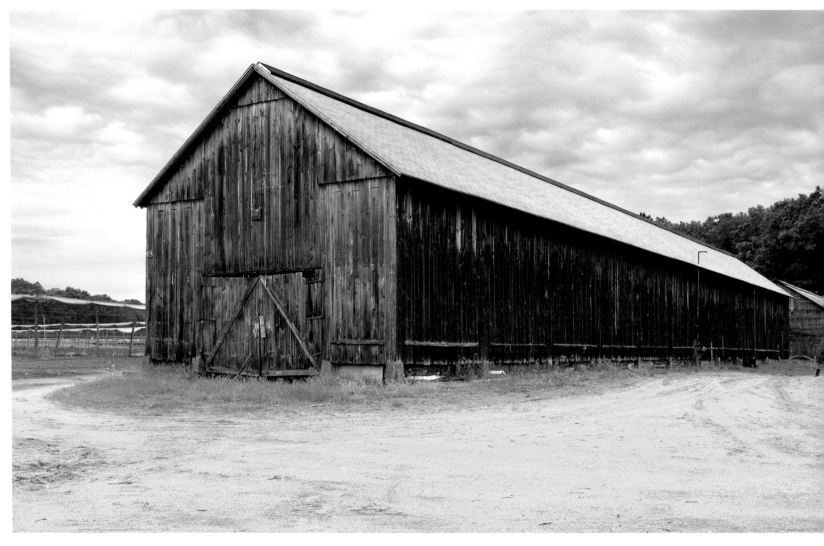

Tobacco barns are perhaps the most widely recognized barns in the state. Groups of these barns can still be found in the Connecticut River valley from Middletown north through Suffield and into Massachusetts.

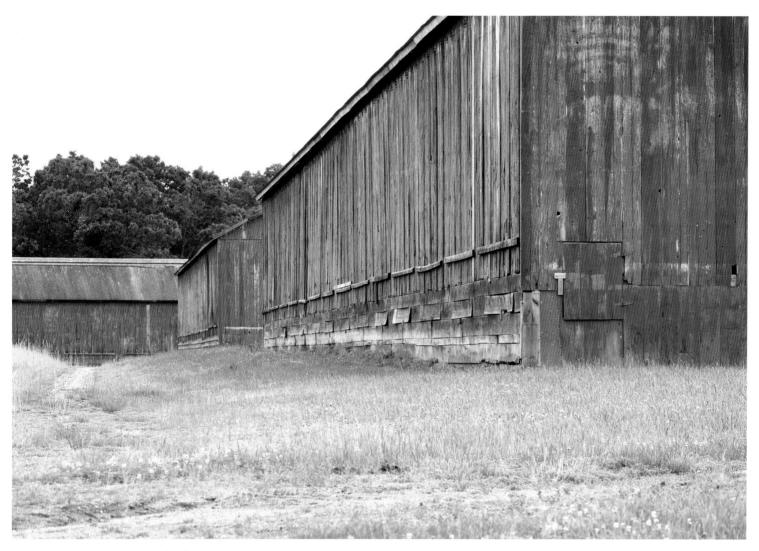

Tobacco barns are used to dry leaves for cigar wrappers. To help with this process, the walls of these barns—or sheds, as they are often called—open to allow air circulation. Every second or third board is usually hinged to swing open. Large hooks and eyes keep the siding closed.

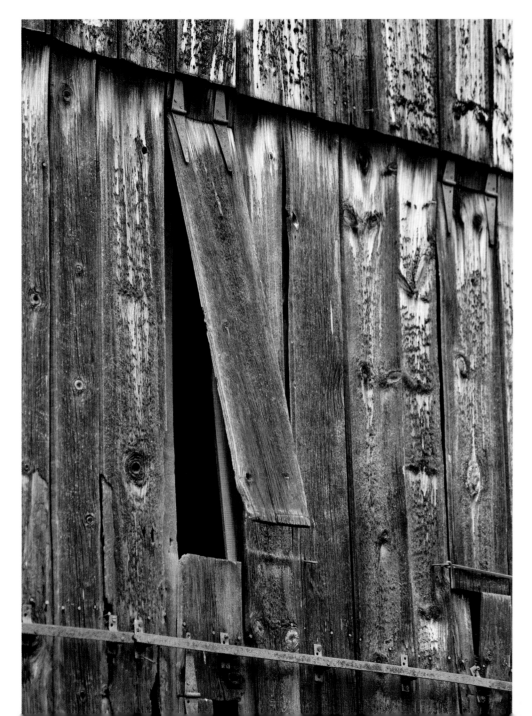

A piece of vertical siding on this tobacco barn is held open by its rusting hinges. Barns were sometimes heated with wood and later propane to help speed the drying process.

opposite:
Interestingly, tobacco barns are generally placed together in large, open fields. A revival in cigar smoking in the late twentieth century helped save these buildings from extinction.

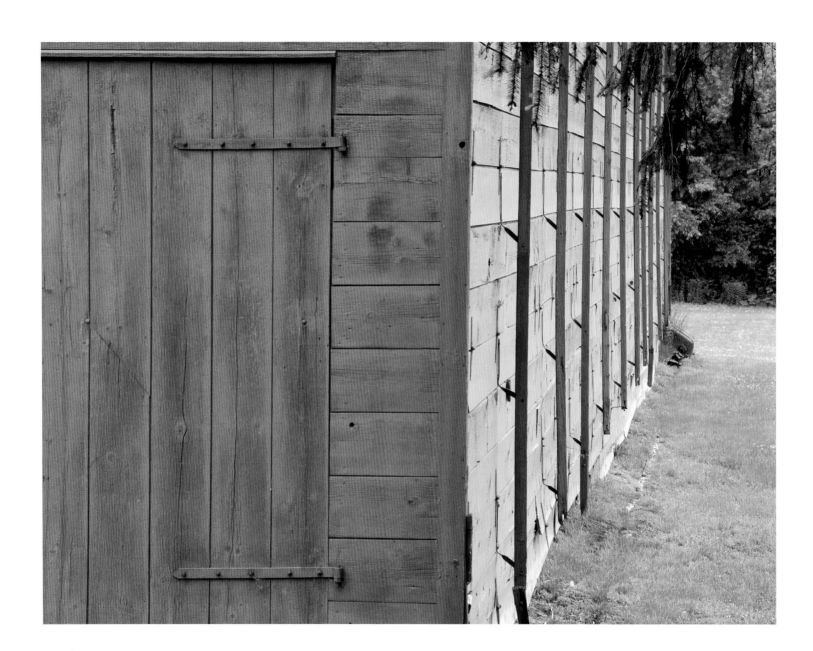

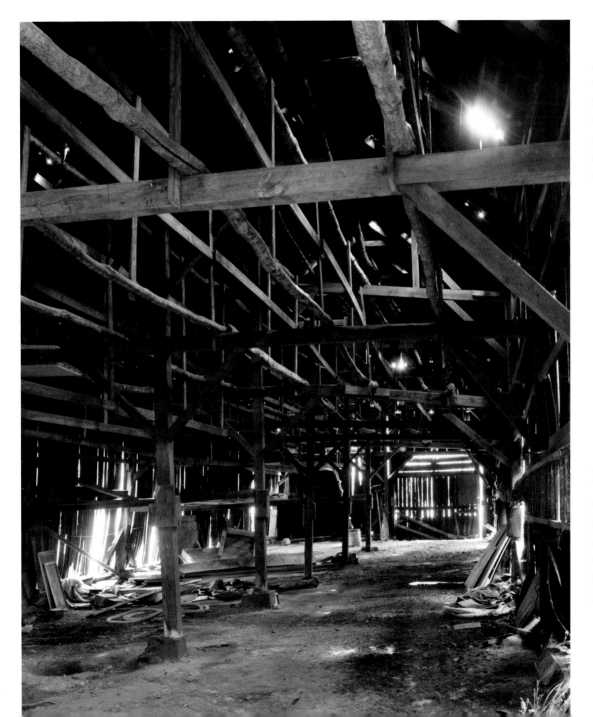

All of the framing inside was used to hang drying tobacco leaves. Because they are lightly built, tobacco sheds are hard to repurpose, a fact that often leads to their demise.

opposite:
Unlike later barns, on which siding runs vertically, this restored tobacco shed employs horizontal siding that is louvered and can be opened and closed by moving the attached bars.

129

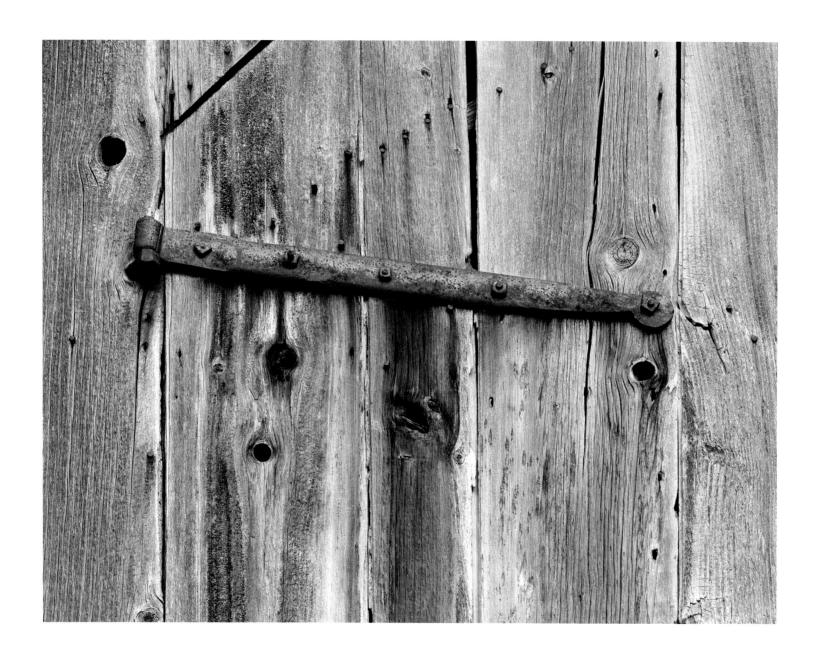

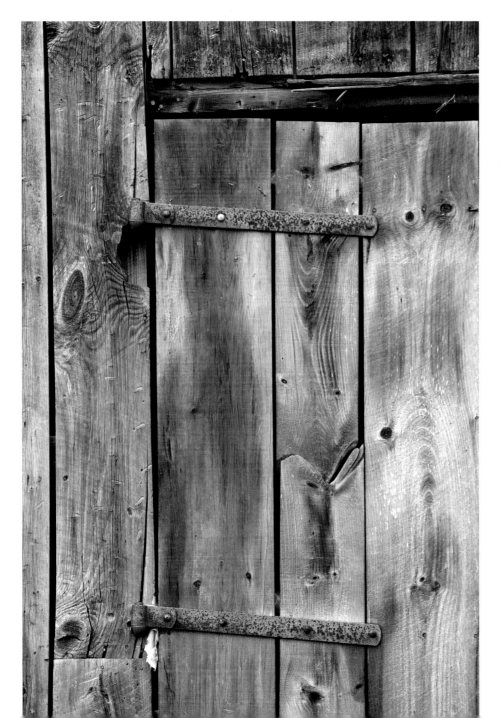

Note the differences between this factory-made hinge and the hand-forged hinge featured in the previous photograph. The decorative end the blacksmith applied is gone; this hinge is simply rounded off. While just as functional, it has lost its elegance.

opposite:
This hand-forged hinge, made by a blacksmith, allows a gable door to swing open near the peak of the roof.

Even hinge technology changes, as illustrated here by the use of a stamped strap hinge to hold up a small door on the side of a beautifully weathered barn.

These two small barns supplement the main barn across the road, although their original purpose is not obvious.

This shed is either an early A-frame construction, or the walls and frame beneath the roof rotted and the owner decided to extend the life of the building.

The location of this little barn just off the kitchen ell of the farmhouse makes it perfect for firewood storage. This farm has been operated as a dairy farm by the same family for nearly a hundred years.

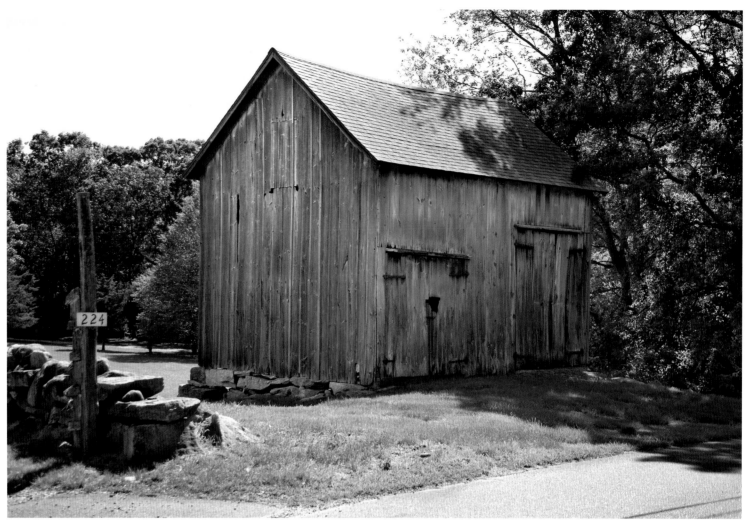

Unassuming barns like this were once found on nearly every road in the state. A little bit of stonework, a little bit of woodwork, and a building that has served for a century.

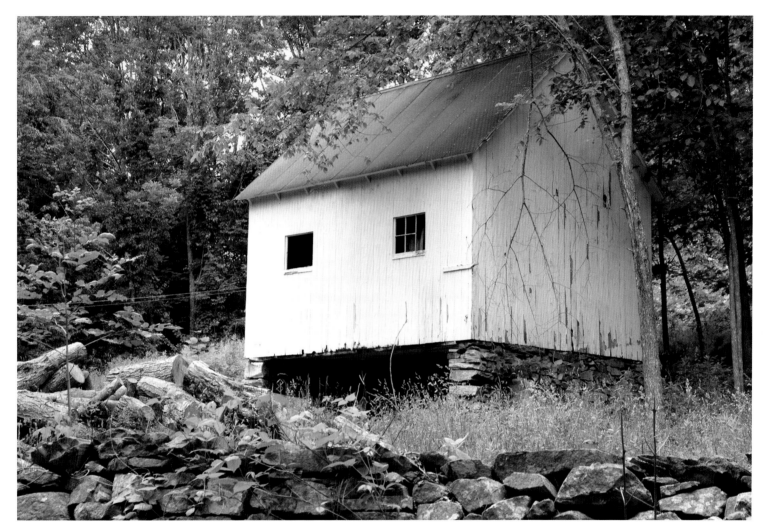

Even into the late nineteenth century, simple outbuildings like these retained hewn floor joists, with only the top of the log hewn flat. Far removed from the house, this building may have been used as a workshop and not for farming purposes. Of course, the woods surrounding it today were probably open fields when this building was constructed.

Corn cribs didn't show up until the mid-nineteenth century. Their distinctive slanted and vented walls allowed for airflow but kept rain and snow from entering. This crib has an unusual shed addition—probably for equipment storage. The hinges on the doors are hand forged.

opposite:
The main barn could not always accommodate crop storage, so farmers constructed smaller outbuildings, like this well-preserved corn crib, to handle the overflow or specialty crops.

This crib's days are numbered. As mice and rats also love corn, cribs were generally built high off the ground on stone posts. To further discourage rodents, large flat stones or metal plates were placed on top of the posts.

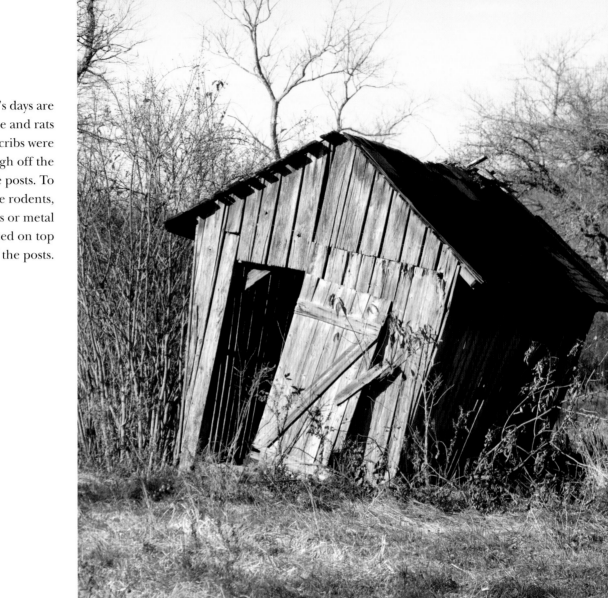

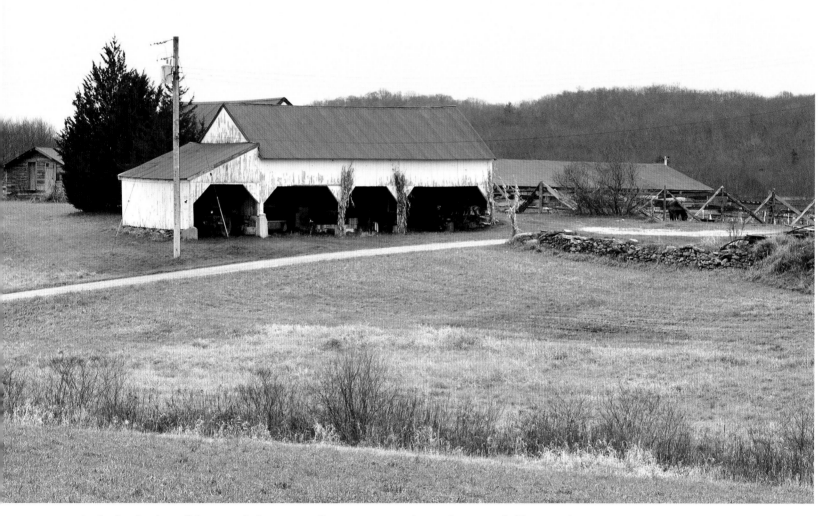

At the beginning of the twentieth century, farm tractors took over heavy work. To store these valuable machines and their attachments, specialty sheds were built. The three-bay shed shown here could also accommodate hay in the loft above.

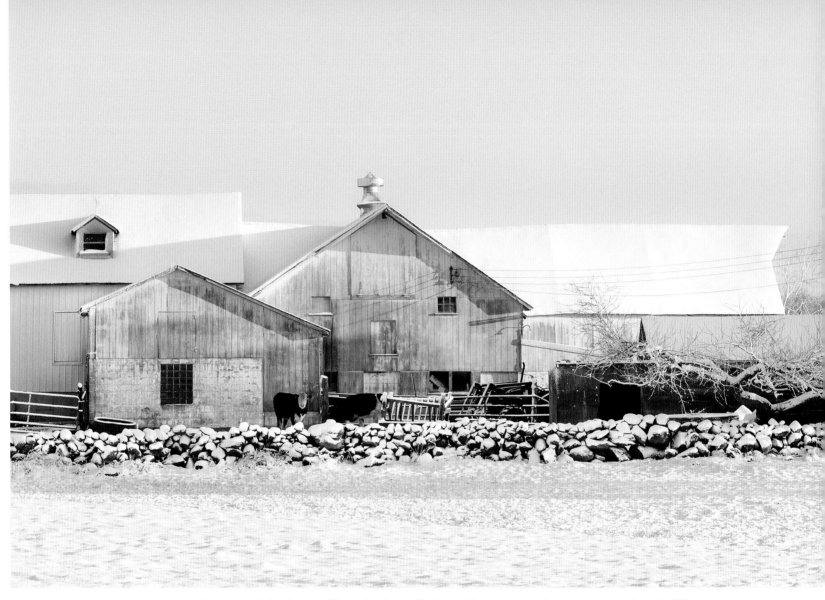

This small dairy farm, still producing milk, has added nearly a dozen barns and outbuildings over the years to accommodate the work they do.

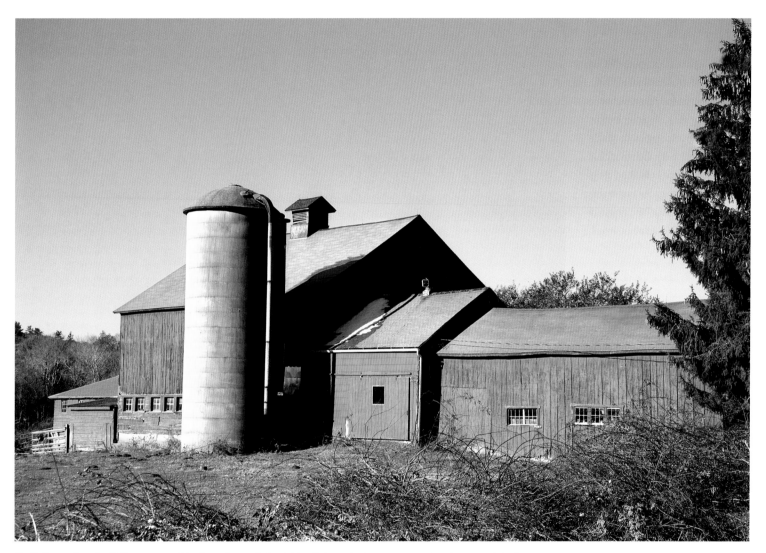

Building after building was added to the original English style barn as production on this farm expanded. Note the stacked concrete rings on the grain silo, just one of dozens of construction methods used to build this type of storehouse.

Hidden behind this towering silo is an early English style barn. The cinderblock addition to the right is the milk room. State health regulations forced dairy farmers to install concrete floors in milking parlors and stainless steel holding tanks in milk rooms.

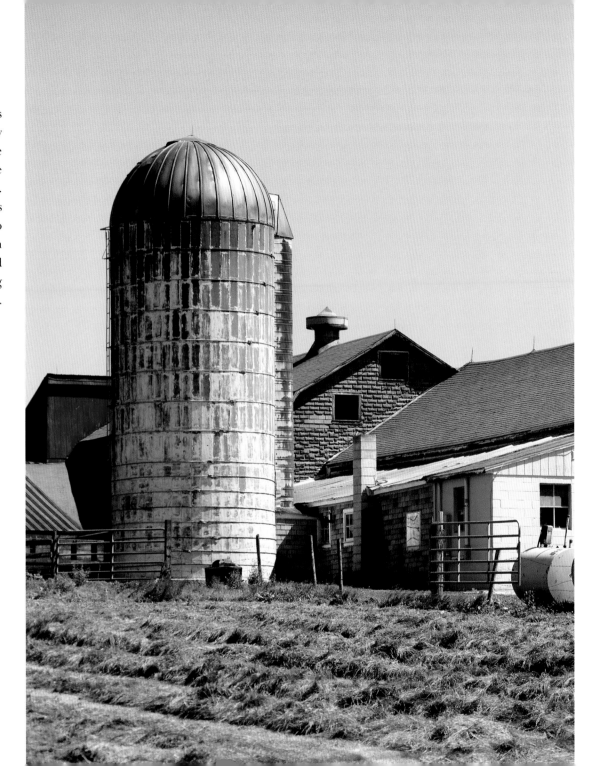

Farmers, of course, often favored animals as subjects for this much-loved barn feature, the weathervane. This elegant pig stares intently off to the northwest.

This is the rooster that
tops the carriage house
on page 94.

The cow is the preferred animal for most dairy barns. Companies that sold ventilators were only too happy to add these decorative touches.

Tradition finally died in the twentieth century. Timber-framed barns, while still occasionally built, became a rarity. This barn maximizes space with a minimum of materials. Asphalt roofing was the cheapest and most efficient building material available for this arched frame.

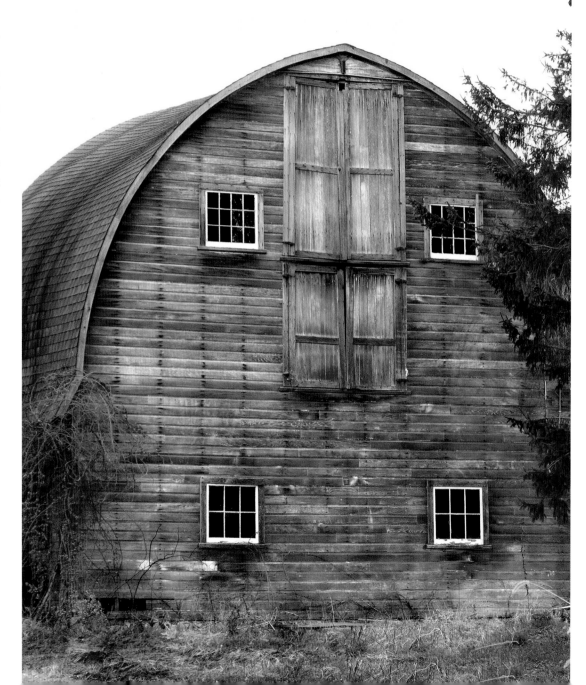

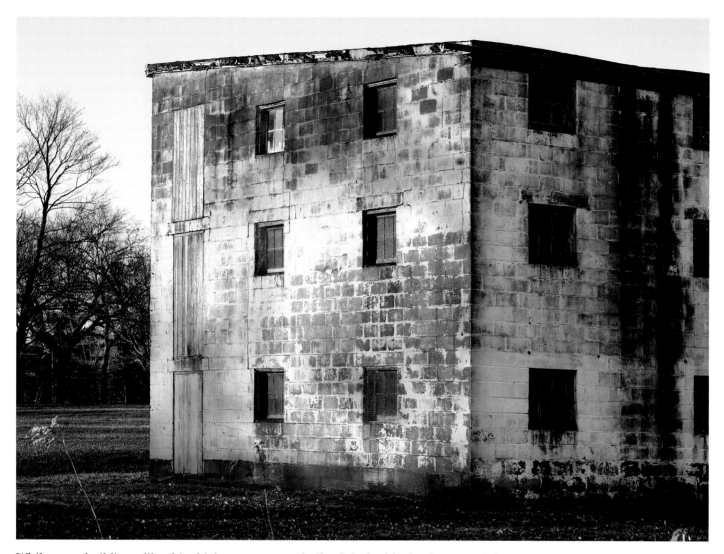

While some buildings, like this chicken coop, were built of cinder blocks, that material never took off for the general farm barn, although block foundations rapidly replaced once standard stone foundations.

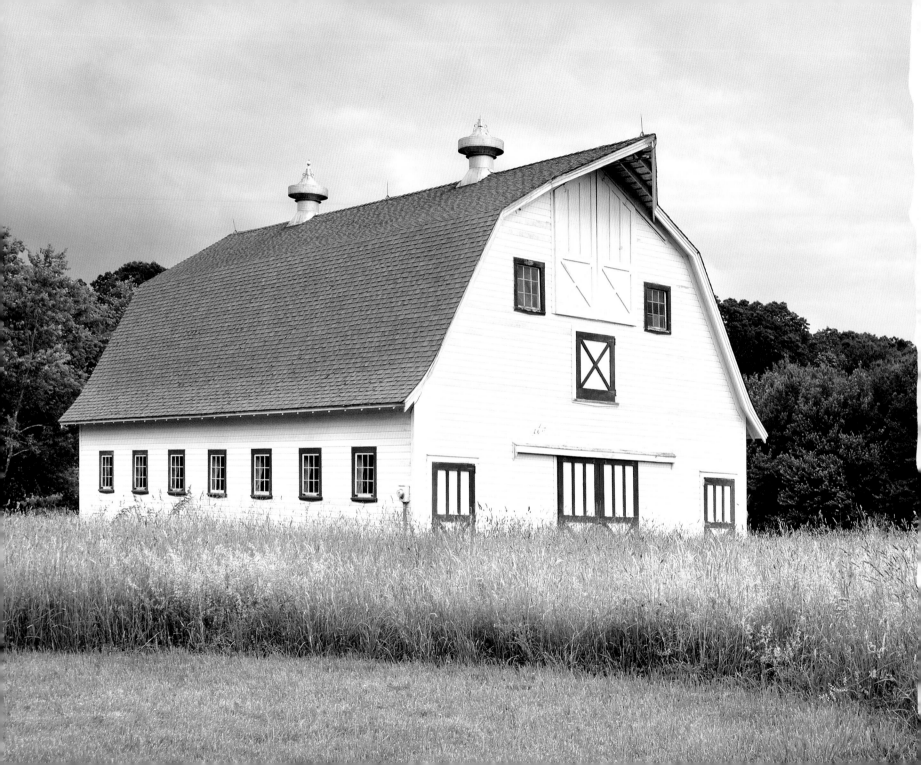

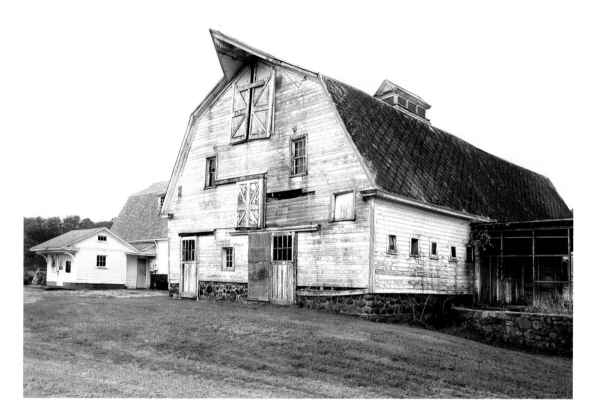

The massive loft doors at the peak slide down tracks under the rakes to allow for an elaborate hay-moving system. Elevators moving baled hay eventually replaced tracks with horse forks moving loose hay.

opposite:
While houses had been built with gambrel roofs in the late eighteenth century, they were not used in barn construction until the late nineteenth century and, even then, only sparingly. Perhaps that was because of the additional complexity required to frame them with timber. As with the round-top barn, twentieth-century framing methods simplified the framing process and helped popularize gambrel roofs.

This old elevator was used to lift hay bales up through loft doors where waiting workers stacked them.

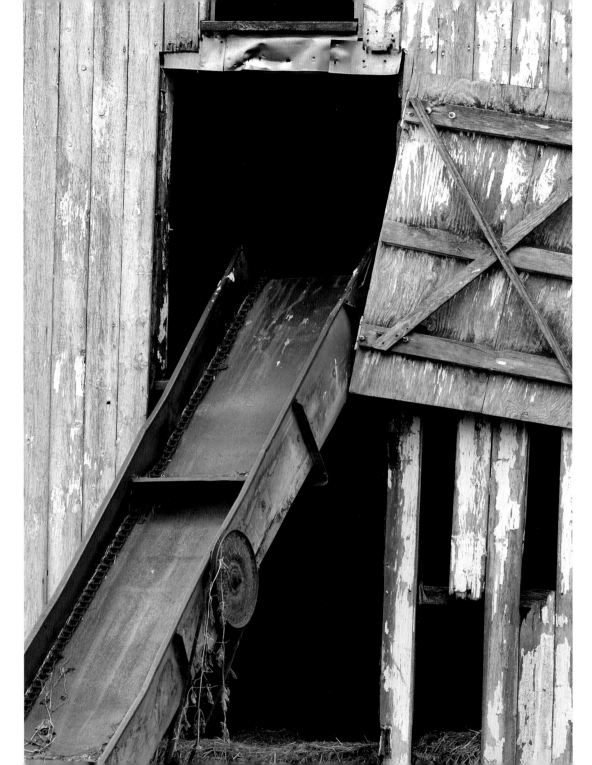

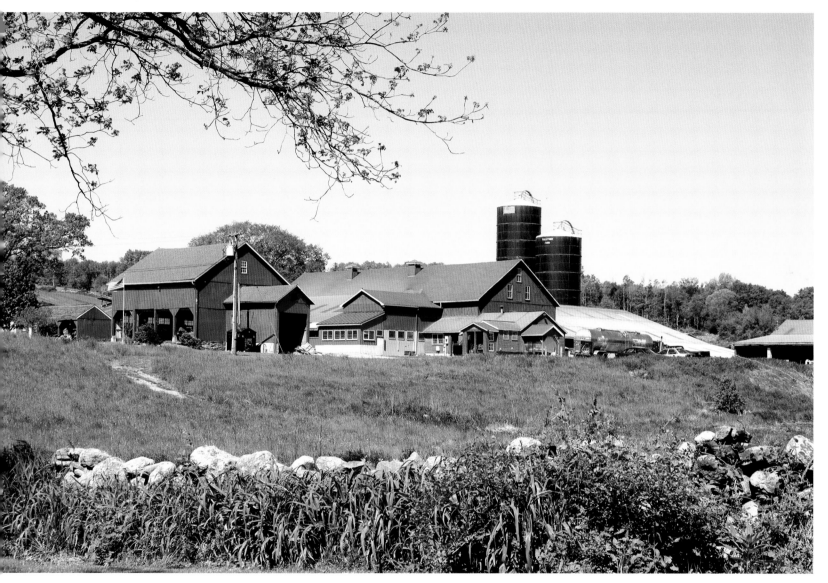

Some 250 family-operated dairy farms remain in Connecticut.

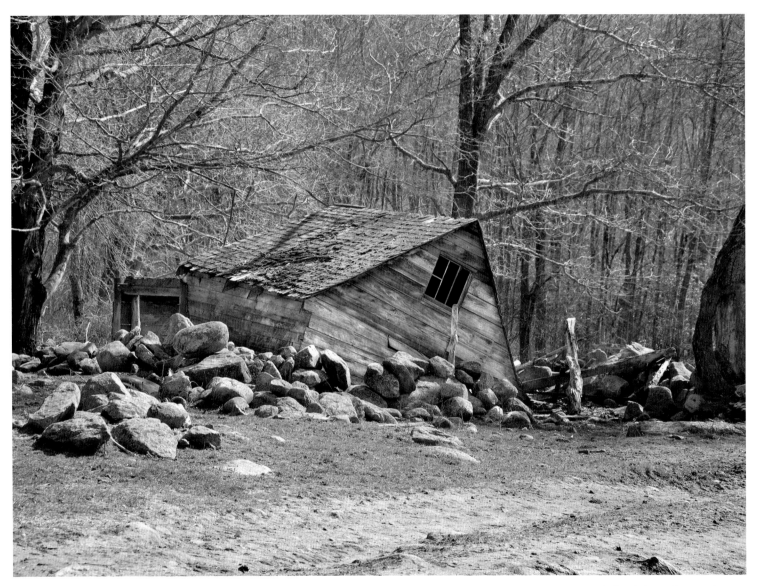

A sight now all too common in Connecticut. This small barn seems to melt back into the earth.

Acknowledgments

I have studied architecture and barn construction off and on for more than thirty years, having first worked as a restoration carpenter for a large maritime museum before starting a timber framing company dedicated to building reproduction homes and barns. Because of my interest and occupation, I read everything I could find on Connecticut barns, and I carefully studied the historic barn frames I was privileged to repair.

I began work on this book by refreshing my memory with the texts listed below. Visser's book was certainly the most important reference. The dates listed throughout this work are based entirely on his research. It is certainly one of the most important books on New England's farming structures, and I am entirely indebted to his wonderful work. While the other books deal with domestic or public architecture, the light they shed on timber framing practices applies to barns as well. Kelly's book on domestic architecture is a bible in its field, especially for his understanding of colonial builders and their practices. His drawings of roof structures for every meetinghouse in Connecticut up to 1830 in his work *Early Connecticut Meetinghouses* are exceptional and gave me an appreciation for the conservative nature of timber framers in America up to the Industrial Revolution. The Dover reprints of Asher Benjamin's builder's manuals from the early nineteenth century were as useful to me when building period reproductions as the original publications must have been to carpenters of his day.

ABOUT THE AUTHOR

MARKHAM STARR is a documentary photographer and the author of *End of the Line: Closing the Last Sardine Cannery in America, Building the Greenland Kayak, Down on the Farm: The Last Dairy Farms of North Stonington,* and *Finest Kind: The Lobstermen of Corea, Maine.* His photographs have been featured in *Yankee Magazine, Rhode Island Monthly, LensWork,* and others, and are part of the permanent collection at the Library of Congress.